Down Garden Paths

The Floral Environment in American Art

Down Garden Paths
The Floral Environment in American Art

WILLIAM H. GERDTS

Rutherford • Madison • Teaneck
Fairleigh Dickinson University Press
London and Toronto: Associated University Presses

Associated University Presses
440 Forsgate Drive
Cranbury, New Jersey 08512

Associated University Presses
25 Sicilian Avenue
London WC1A 2QH, England

Associated University Presses
2133 Royal Windsor Drive, Unit 1
Mississauga, Ont. L5J 1K5, Canada

Library of Congress Cataloging in Publication Data

Gerdts, William H.
 Down garden paths.

 Includes catalogue of the exhibition presented at
the Montclair Art Museum, Montclair, N.J., Terra Museum, Evanston, Ill.,
and Henry Art Gallery, University of Washington, Seattle.
 Includes bibliographical references and index.
 1. Flowers in art—Exhibitions. 2. Wild flowers in
art—Exhibitions. 3. Gardens in art—Exhibitions.
4. Painting, American—Exhibitions. I. Montclair Art
Museum. II. Terra Museum of American Art. III. Henry
Art Gallery. IV. Title.
ND1402.5.G47 1983 758'.42'0973'07401731 83-16335
ISBN 0-8386-3214-9

Printed in the United States of America

Contents

Foreword

THIS BOOK TRACES A MOVEMENT IN AMERICAN FLOWER PAINTING HITHERTO UN-studied—the departure from arranged still lifes and the emergence of paintings showing flowers growing in a garden or in the wild. It is a genre, influenced by Ruskin and Monet, that mirrors the 19th century American veneration of nature. Because the Montclair Art Museum is known for its collection of American art, it is particularly gratifying to us to publish this book and to present an exhibition of some 100 works splendidly illuminating the theme.

It is most fortunate that Dr. William H. Gerdts, the author of this book, has also served as a guest curator of the exhibition. His impeccable scholarship, superb eye, and wide knowledge of public and private collections of American art all over the United States have produced an exhibition which is ravishing in its sheer beauty and accurate and complete in its delineation of the genre with which it is concerned.

We are very pleased to be able to send the exhibition to the Terra Museum, Evanston, Illinois, and the Henry Art Gallery of the University of Washington in Seattle, thus bringing this magnificent assemblage of works to a wider audience. I extend deepest appreciation to all those who extended the loan of their works to make this tour possible.

For their special courtesy and assistance, I am particularly grateful to Bruce Bachman of the R. H. Love Galleries, Inc.; Jeffrey Brown of Jeffrey Brown Fine Arts; Stuart Feld of Hirschl & Adler; James Berry Hill of Berry-Hill Galleries, New York; John Howat and Doreen Burke of the Metropolitan Museum of Art; Harry Lowe and Melissa Kroning of the National Museum of American Art; Ron Melvin of the Terra Museum; Sam Miller of The Newark Museum; Sheila W. and Samuel M. Robbins; Ira Spanierman of Ira Spanierman, Inc.; Robert and Abbot Vose of Vose Galleries of Boston; John Walsh, Jr. and Eleanor A. Sayre, Museum of Fine Arts, Boston; Harvey West of the Henry Art Gallery; and all of the lenders.

Robert J. Koenig
Director, Montclair Art Museum

Acknowledgments

THE AMOUNT OF COOPERATION AND ASSISTANCE RENDERED THE AUTHOR IN THE preparation for the *Down Garden Paths* exhibition and this accompanying book was enormous, and it would be impossible to offer a full tabulation of acknowledgment and gratitude here. A legion of scholars, museum personnel, dealers, and private collectors were generous with their information and with their treasured works of art, including, of course, the many lenders to our exhibition. I must congratulate and thank with pleasure Stephen Edidin for his painstaking and thorough analysis of garden literature of the period, which has so enriched not only the following essay but the overall concept of the show. Frances Weitzenhoffer gave generously of her knowledge of the dissemination of French Impressionist painting in America and provided an introduction to Jean-Marie and Claire Joyes Toulgouat of Giverny, discussions with whom were of special significance in understanding the early manifestation of the theme of this exhibition. Jeffrey Andersen of the Lyme Historical Society was particularly helpful in regard to the paintings of the floral environment produced by artists in Old Lyme. Others who extended themselves, not only beyond the ordinary but even beyond the extraordinary, include Stuart Feld and Jeffrey Brown. And a word, because a debt, of special gratitude is reserved for Arthur Altschul and the Altschul family, who generously filled an especially significant lacuna when it suddenly developed in our planning, and thus tremendously reinforced perhaps the central issue of our historical survey of the theme. To Director Robert Koenig and the staff of the Montclair Art Museum—Lillian Bristol, Mary DeMaio, Joan Lorenson, Hope Morrill, and Rita Arnheiter—my thanks for a superb working relationship. Finally, to my wife, Abigail, my total gratitude for her constant support and her superb insights, here as always.

William H. Gerdts
The City University of New York

Down Garden Paths

*The Floral Environment in
American Art*

. . . .not until the Impressionists of a later century conceived the idea of painting in the open air did the flower-painter seek the open fields where growing flowers show their full glory of color under the rays of the sun. In contrast to the formality of the early indoor bouquet, we find quite as interesting the flower arrangements given us by those who seek their flower-subjects in the sunshine of outdoors. Here are nature's beautiful blossoms found in great masses on the hills, bending to the summer wind, or in those formal masses of the protected garden, so deftly arranged for contrast of color. Indeed the garden under the glowing sunlight offers an endless number of themes for the brush of the flower-painter. The combination of flower and landscape is not unusual, but it is only recently that in such pictures predominance has been planned for the flower part of the picture.

<div align="right">

Ida J. Burgess, "Modern Flower-Painting,"
The Lotus, January, 1920

</div>

Down Garden Paths

THE PRESENT VOLUME IS, LITERALLY, AN *ANTHOLOGY* OF LATE NINETEENTH AND early twentieth century American paintings exploring and utilizing the floral environment. "Literally," because, though it has come to mean a more general collection of, usually, literary materials, the word *anthology* is from the Greek term for a gathering of flowers. This presentation of works of art is thus, in fact, a pictorial anthology of floral paintings in both the antique and modern senses. These are pictures in which flowers play a major, often dominant part, but they are not still lifes. Rather, the exhibition documents the release and expansion of the floral theme, where the flowers suffuse and pictorially perfume the environment, and where often that environment is, itself, the subject of the picture. As such, the flowers in these paintings are usually still growing, still living entities.

A generic name for this kind of painting might be the "garden picture," but that is incorrect on several scores. First of all, the works under consideration encompass more haphazard arrangements and nonarrangements of fields of flowers—"natural" arrangements if you will—though in view of the nature of the preferred garden aesthetic of the time which recommended a "natural" garden rather than a formal one, the distinction between the two themes, or sub-themes, is somewhat obscure. Both of these pictorial subjects rose to tremendous popularity in America and in Europe in the late nineteenth century, and variations on the theme of the floral environment, such as depictions of flower shows and flower markets, were also explored.[1]

Conversely, not all gardens, and not all garden pictures, are concerned with flowers. Certainly, both art and literature were tremendously richer in their concern with flower gardens than with vegetable gardens, but there was a surprising number of paintings done of farmers and peasants tending vegetable gardens in the late nineteenth century—more in European art, relatively few in American (this is a theme which did *not* inspire a comparable literary equivalent). Popular as this alternative theme was, however, it drew from a

very different pictorial source, the exploration of peasant life, whether ennobled and inspired, downtrodden, or nostalgic.[2]

The flower garden and its related imagery were painted to embody and inspire very different values and sensations. Though each sub-theme of the floral environment upheld somewhat different qualities and standards which should be separately recognized, the flower is the common denominator of them all. The painters of all these pictures exploit the sensuous appeal of the flower—primarily its appeal to sight, in the myriad of brilliant hues, the variety of shapes, and often the incalculable profusion of blooms. There is also the synesthetic suggestion of the scents of the flowers, and the appeal of texture, though in the period under consideration, that texture more often than not found a rough (sometimes literally!) equivalent in a painterly impasto rather than pictorial mimesis.

The garden picture, of course, was hardly new to art in the late nineteenth century. Indeed, its pictorial history is one of long duration, going back at least to the late Middle Ages, and the *hortus conclusus,* the enclosed garden, symbolic of the Virgin and the Immaculate Conception, or the Garden of Paradise. As such, the flowers of these gardens stood for beauty and symbolized goodness as a natural carpet onto which no evil could encroach, this in addition to the more specific meanings which individual flowers might embody symbolically. Such Biblical gardens remained themes of fascination for many a master of the early Renaissance, such as Fra Angelico, though increasingly they became opportunities for naturalistic and botanical exploration as well as representation of holy ground.

The depiction of an environment of flowers became ever more naturalistic, and ever more elaborate through the Renaissance, culminating in such works as Jan Brueghel's tapestried garlands surrounding images of the Madonna, or sometimes even a whole landscape tableau in which Mary is immersed, still enclosing and sealing in impregnable beauty the holy and maternal image from the outside world—the purity of womanhood surrounded by a profusion of flowers, the ancient symbol of Venus and of love. Strangely, however, the flower garden, itself, somewhat abruptly all but disappears as a serious motif in Western art in much of the seventeenth century, almost surely in part due to the extreme formality of real garden design of the period, wherein the flower of arbitrary growth and color had no place.

Even in the eighteenth century, the more capricious approach toward the pictorial environment, and the increased informality of garden design, did not greatly return the flower to its habitat as a prominent painting motif. There was some recognition, certainly, of the symbolic role of the flower as an emblem of love in the garden settings for romantic dalliance in paintings by such French rococo masters as Boucher and Fragonard while in still-life painting somewhat informally arranged flowers in outdoor settings appear in pictures by masters as diverse as Francesco Guardi and Jean Baptiste Oudry. While neither still-life painting nor scenes of amorous play within a garden setting received serious consideration or aesthetic approval during the ensuing neoclassic period, Romantic painters, such as Delacroix, injected a new vitality and pictorial richness in depicting an abundance of flowers in an outdoor landscape setting.

In America, there existed no tradition at all for the depiction of the floral

environment, and even flower painting itself—that is, the floral still life—was an exceedingly infrequent pictorial subject until the 1840s, and only began to enjoy sustained expression in the following decade. The floral environment, as distinct from the arranged bouquet in a vase upon the tabletop, owes its American pictorial origins to a number of sources. One of these is the landscape or nature study, that is, direct outdoor or *plein-air* painting which began to be practised more and more from the 1840s on, though only gradually, as alternative to the older methodology of drawing or sketching "from nature." Whether the artists of the mid-nineteenth century drew or painted outdoors, their finished works were composed and created in the studio, but a reliance upon painted studies done on the spot necessarily tended to image Nature more transcriptively, with less concern for the creation of "compositions." Outdoor painting did not necessarily exhibit floral accretions, but obviously the appearance of brightly colored individual blooms or carpets of color, as in the outdoor studies of such mid-century masters of landscape as Frederic Church and Albert Bierstadt, were more likely to be retained in finished exhibition pictures than a mere notation on a pencil drawing that flowers were present. It should be stressed of course that such oil studies as those in the present exhibition were painted for private consultation as part of the artists' methodology; they were not for public exhibition or consumption. Still, they constitute one factor in the emergence of the floral environment in American art.

Undoubtedly more significant were the writings of the English aesthetician and critic, John Ruskin, whose works began to appear in England in 1843 and found American publication as early as 1847. Ruskin wrote in 1857 that: ". . . the most beautiful position in which flowers can be seen is precisely the most natural one—low flowers relieved by grass or moss, and tree flowers relieved against the sky." As opposed to the "old Dutch artists and their contemporary followers who rejoice in flies which the spectator vainly attempts to brush away," Ruskin stated in 1899 that: "A flower is to be watched as it grows in its association with the earth, the air, and the dew; its leaves are to be seen as it expands in sunshine; its colours, as they embroider the field." Ruskin called for a fidelity to Nature which he found wanting in most of the painting of the time, a fidelity that would reveal the natural history of the scenes portrayed.[3]

The American followers of Ruskin, whose writings were tremendously influential in this country for about two decades beginning in the late 1840s, took their mentor very much to heart, though these artists and critics were, and to some extent still are, relatively little known. One of them was Henry Roderic Newman, who was involved with the Ruskin- and Pre-Raphaelite-inspired movement in New York in the early 1860s, The Society for the Advancement of Truth in Art, but in 1870 settled in Italy for his health. There he continued to follow Ruskin's aesthetic prescriptions, devoting much of his artistry to the depiction of the Florentine anemone; as one biographer wrote, "It is from the wild *Anemone coronaro* that he obtains the most poetic combinations."[4] Ruskin thought so too. Newman's painting was first brought to the Englishman's attention in 1877. In the spring of 1881 Ruskin selected a series of watercolors of Florentine anemones as models of flower drawings, and acquired studies of Florentine roses and of plums as well. The anemone picture in the present exhibition is similar to several that Ruskin owned, and

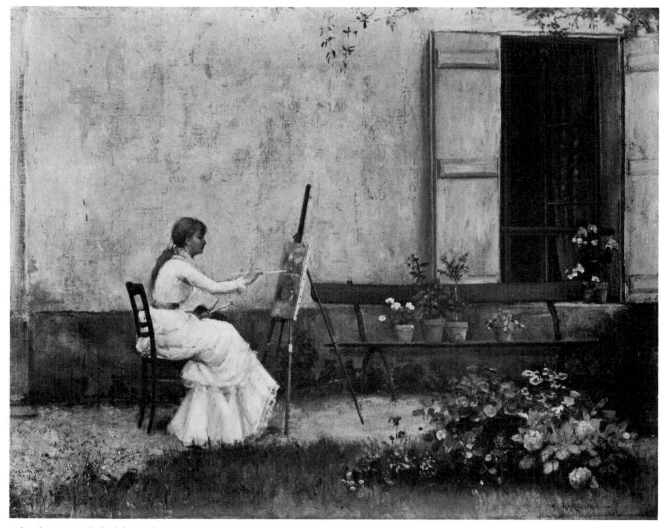

Abraham Archibald Anderson
 (1847–1940)
French Cottage, 1883

is painted in Newman's quite individual approach to the depiction of flowers in their environment. As one biographer wrote of such paintings: "Mr. Newman selects foregrounds full of flowers, and paints those foregrounds at the shortest possible range . . . Each blossom as faithfully rendered by Mr. Newman seems to have its own life and passion . . ."[5]

The most talented and famous of the Americans in Ruskin's orbit, William Trost Richards, represented here by a beautiful early garden scene, was seldom a painter of flowers, but his pupil and follower, Fidelia Bridges, specialized in painting fields of flowers and grasses, some of which were popularized by Louis Prang in a marvellous set of chromolithographs of *The Months.* More generally influential than his specific words on flowers as subject matter was Ruskin's insistence upon a preference for a natural setting for the rendering of natural (i.e., nature-derived) forms, which tended in the 1860s and afterwards often to obscure the distinction between still life and landscape. In most paintings of fruit quixotically positioned in a landscape

glade or upon a rocky ledge, the still-life aesthetic is clear enough, but in the rendition of flowers, the thematic category of still life is enlarged and enhanced by the presence of the growing flower. Particularly in Martin Johnson Heade's marvellous series of tropical orchids and passion flowers, accompanied by elegant hummingbirds, the result of his visit to Brazil in 1863, the

Karl Anderson (1874–1956)
Wisteria, 1915

concentration, as in all still-life painting, is still on the individual blossoms, but these snake their way through a lush but slightly ominous landscape, a sensuous, even eerily sexual presence in a tropical garden of Eden. These are at least living still lifes, and scarcely "still" at that.

The natural setting still life found its most poetic interpretation, with less botanical documentation than Newman or Heade, in the water lily paintings of John La Farge. In some ways, La Farge's flower pictures, both the oil still lifes of the 1860s and the watercolors of the '70s, are the antithesis of Ruskin's insistence upon the pictorial rendering of natural history. This emphasis upon the poetic and aversion to the botanical rendering led the noted writer and critic, James Jackson Jarves, to describe La Farge's flower paintings in the following manner: ". . . they are as tender and true suggestions of flowers as nature ever grew, and affect our senses in the same delightful way. Their language is of the heart and they talk to us of human love and God's goodness. We bear away from the sight of them, in our inmost souls, new and joyful utterances of nature." And recalling his flower paintings, La Farge himself reminisced: "Some few were paintings of the water lily, which has, as

Gifford Beal (1879–1956)
The Garden Party, 1920

Albert Bierstadt (1830–1902)
Field of Red and Yellow Wildflowers

you know, always appealed to the sense of something of a meaning—a myste-
rious appeal such as comes to us from certain arrangements of notes of
music."[6]

In a manner more sharply, carefully delineated, more clinical and botanical,
and less poetic are the flower paintings of George Lambdin, who along with
Heade and La Farge was one of the earliest significant flower specialists in
America. Lambdin had begun his painting career as a specialist in genre
subjects, often scenes of small children or alternatively, of lovely young
ladies, and some of these combine the attractive, pensive lady with the appro-
priately attractive setting among picked flowers indoors or a bower of blooms
outside, at times with titles such as *Rosey Reverie*. Roses were Lambdin's
favorite blooms, and he went on to develop one of the best-known of the
many famous flower gardens in Germantown, outside of Philadelphia. This
garden was the basis for the series of rose garden pictures that he painted
once he turned more and more to still-life specialization, after about 1870.
Lambdin painted many beautiful flower still lifes in a conventional format of a
bouquet in a vase upon a tabletop, but more innovative was his adaptation of

Franz A. Bischoff (1864–1929)
Peonies

the Ruskinian aesthetic to the interpretation of his own garden, the depiction of growing flowers usually silhouetted against a slightly textured wall of stucco or plaster. In these pictures, the flowers are usually shown in a seemingly informal setting and arrangement, but actually beautifully arranged in sinuous arabesques of stems and blooms, wherein the natural life cycle of bud to full flower to ageing bloom is well observed and delineated.

Roses, indeed, abound in Lambdin's work; such a painting as his *Roses in a Wheelbarrow* is a variant of his more usual depictions of growing flowers, but they are still outdoors, and this is still, in effect, a garden painting. The artist incorporated the rose, too, even in his formal portraits where, as he said, ". . . the roses upon the ladies' cheeks have been repeated in the roses in their hands, or ornamenting their dresses."[7] So well associated was Lambdin with the rose that the full range of his floral interests and accomplishments is only now coming to be appreciated, with his paintings of various kinds of lilies, or the lovely *Wisteria on the Wall* of 1871 in the present show. These paintings of living flowers, under the artist-gardener's own cultivation, though accurately, even scientifically described, are not painted in a Pre-Raphaelite manner.

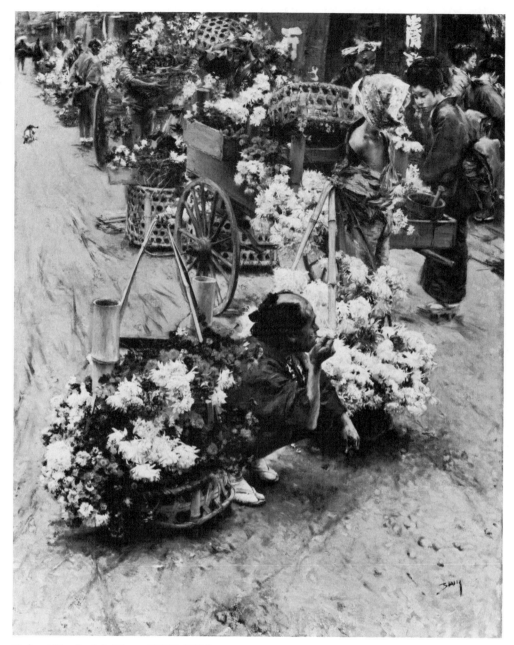

Robert Frederick Blum (1857–1903)
The Flower Market, Tokyo, ca. 1891

However, the basic format, the informal setting and arrangement, and the depiction of a natural growth cycle are derived from Ruskin and reflect the impact of the writings of Charles Darwin. This is a form of painting in the gray area between landscape and still life: more than nature studies, but distinctively removed from the traditional floral still life in which Lambdin was also a specialist of the first rank.

The flower *garden*, as a separate theme distinct from the outdoor still life, developed exceedingly slowly in American art, lacking as it did a tradition. Its origins probably lie at least in part in the vernacular. One of the earliest

John Leslie Breck (1860–1899)
Garden at Giverny, ca. 1887

professional examples known is by the Bangor, Maine, portrait painter, Jeremiah Hardy, which probably exists simply because its subject was there. It is a depiction of Hardy's wife in the Hardy garden; and in 1855 he painted her as enshrined in a Down East *hortus conclusus* though one feels a very real presence in a naturalistic environment—a Paradise Garden which existed because she tended it.

Artists such as Winslow Homer occasionally painted garden pictures in the 1870s in a more informal, somewhat fresher and freer manner. Homer at the time was allying the attractive young farmgirl—the American peasant-equivalent, free from the burdens of oppressive toil—with the casual garden. Flowers were not a major element in Homer's work, but they appear occasionally in his watercolors of that decade, and reappear later in some of his watercolors of tropical Bermuda, where they become rich color accents against a foil of reflected sunlight interpreted as pure, glistening white.

Homer's contemporary, the genre painter Eastman Johnson, was likewise not especially a painter of flowers or the floral environment. However, one of his most engaging paintings, again painted in the "crucial" decade of the '70s, was his *Catching the Bee*, of 1872, depicting an elegant young woman exploring hollyhocks in a garden. It is an exceptionally vivid expression of the outdoors, in rich color and featuring broad, painterly effects in the treatment of the hollyhocks which contrast with the more structured approach to the figure. Johnson elaborated upon *Catching the Bee* in an American masterwork of garden painting, his *Hollyhocks* of 1876.

Hollyhocks is truly the Earthly Paradise reborn, a New World, post-Civil War vision of the sheltered American woman in the enclosed garden. Man—or rather woman—and Nature appear in close and total harmony. The single figure of *Catching the Bee* is repeated in the shadowed area at the left, but she is joined by many more of her sisters—and no males! The wall against which the

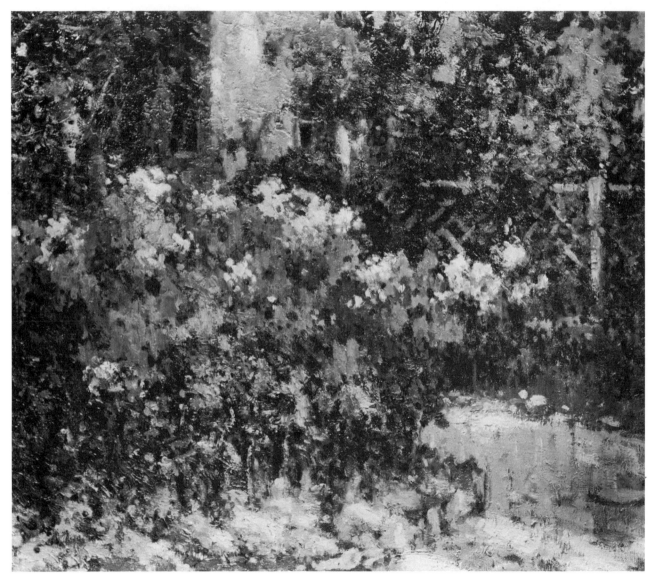

Hugh Henry Breckenridge (1870–1937)
The Flower Garden, 1906

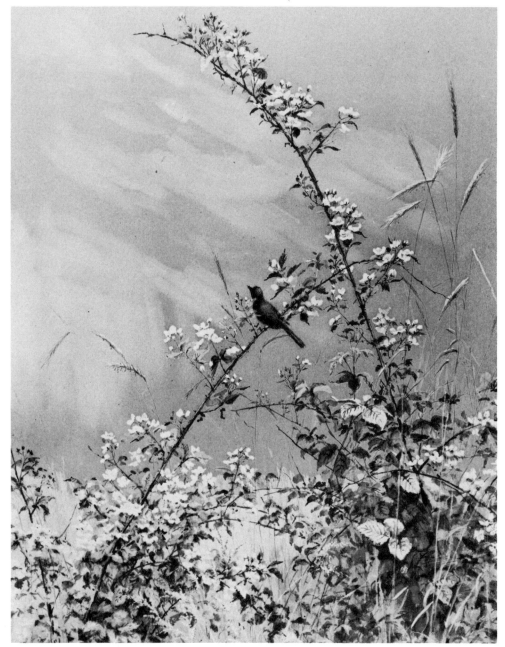

Fidelia Bridges (1834–1924)
Thrush and Field Flowers, 1874

hollyhocks earlier grew is much higher; what in 1872 was a support and a foil for bright sunlight, now is a fortress-like enclosure, both protecting and imprisoning. It is high enough to cast the former sunlight scene in total shadow, but other young women, one in the most virginal of white, appear at the right in the sunshine, examining, comingling with the flowers, some of which arch over the ladies in bower-like fashion.

Unfortunately, such works as these by Johnson have received scant critical attention, emphasis by recent scholars having been given rather to the formal and technical qualities present, while the artist's more frankly social concerns

embodied in scenes of rural genre have attracted greater commentary. Yet, *Catching the Bee* and *Hollyhocks* are fascinating works precisely because of the aesthetic interchange they suggest with contemporary European art, whether or not Johnson was aware of the parallel developments in England and France. The popularity of the depiction of women within the walled garden in Victorian English painting has been exhaustively studied by Susan Casteras, and many of these works offer strong parallels to Johnson's art, though the American pictures lack almost completely the overtones of sexual oppression and sexual frustration that often underlie the English works.[8]

From that point of view, Johnson appears rather to subscribe to the prevailing and earlier American sentiment toward the inspiration of the garden and efficacy of its tending. A reviewer of *Hovey's Monthly Magazine of Horticulture* in 1841 wrote of the moral efficacy of the study of rural beauty as giving it its chief dignity,[9] this the same year which saw the publication of Andrew Jack-

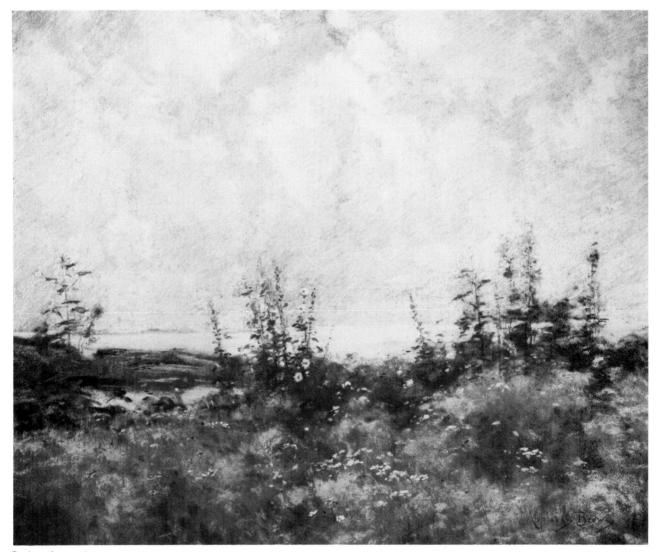

J. Appleton Brown (1844–1902)
Celia Thaxter's Garden—Isle of Shoals,
ca. 1891

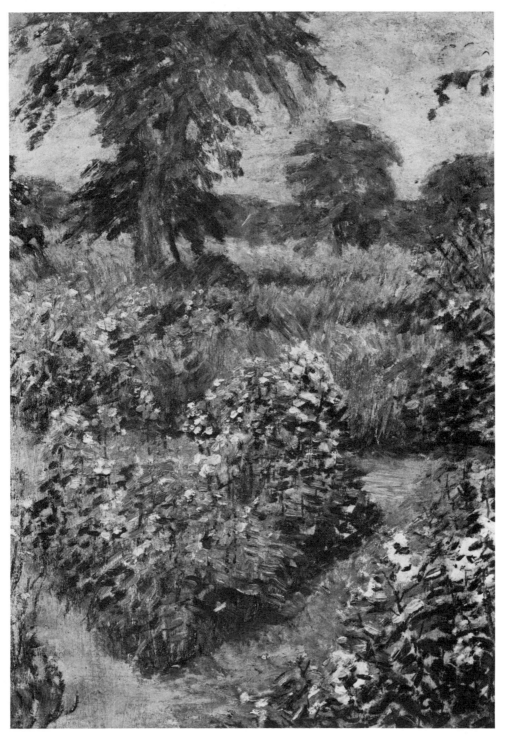

George Brainerd Burr (1876–1939)
Old Lyme Garden

son Downing's landmark publication on landscape gardening, *A Treatice on the Theory and Practise of Landscape Gardening, Adapted to North America.*

The recognition of gardening as an art form goes back many centuries reaching successive apogees in the formal gardens of Le Nôtre in France in the seventeenth century, and in England in the eighteenth. In America, such considerations found their first major expression with Downing. Our concern here, of course, is not with landscape gardening, but rather with flower gardening, with those gardens that are privately cultivated and tended. These gardens—the garden in Johnson's paintings—are adjacent to the home, and serve as an intermediary between Man and Nature; the flower garden thus becomes a sign of unison, a symbol of harmony as expressed in *Hollyhocks.* At the same time, the concern with the enclosed and delimited cultivated garden implies a rejection of the endless wilderness. If Frederic Church's *Twilight in the Wilderness* of 1860 was the paradigmatic expression of pre-Civil War American nature-consciousness, a vision of a New World where no man had ever entered, *Hollyhocks* is an early paradigm of the successive era of ordered, cultivated existence.

If English parallels have not been noted, the similarity of Johnson's work of 1876 to the monumental *Women in a Garden* of 1866 by the Frenchman, Claude Monet, has.[10] Given the thematic similarities of the two paintings, however, their differences, beyond that of scale, ought also to be pointed out. Monet's picture is more expansive and the garden is less enclosed. The figures in Monet's garden move more freely, in less studied cadence because they *are* freer, in their space, to do so. Likewise, the flowers are less prominent, for they do not serve almost as prison bars, as they appear in Johnson's canvas. Because of this, the parallel identification of woman and flower is less insistent in the French painting.

The floral component within the garden environment was to develop continually in Monet's painting, and not surprisingly along with the emergence of the Impressionist aesthetic. One can trace this, reaching an early culmination in the *Artist's Garden in Argenteuil* of 1872; year by year, the gardens in Monet's painting become more encompassing, more colorful and more floral, while the figures themselves diminish in size and significance. Nor were Americans oblivious to these works; the Argenteuil garden scene, in fact, was included in the first important exhibition in this country in which French Impressionist works were prominently displayed, the Foreign Exhibition sent to Boston by the Parisian dealer, Paul Durand-Ruel, and shown there at the Mechanic's Exhibition of 1883.

The introduction and development of the theme of the floral environment in American painting results from the superimposition of the Impressionist aesthetic and Impressionist iconography upon the Ruskinian preference for the informal and uncomposed naturalistic setting, and, in the 1880s, Impressionism meant to Americans Monet above all others. Garden and floral pictures by Monet not only were shown in America in the 1880s, but they were acquired by American collectors. One of the four versions of Monet's 1881 *Stairway at Vetheuil*, for instance, was in the collection of Alexander Cassatt, brother of the American Impressionist, Mary Cassatt. This series, incidentally, provides a significant prototype for the larger series of *Haystacks, Poplars, Rouen Cathedrals* and others beginning later in the '80s. This is not the place to

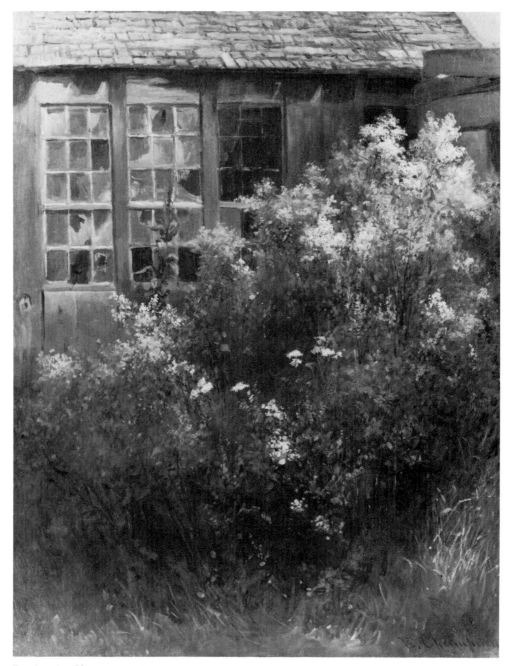

Benjamin Champney (1817–1907)
The Artist's Studio

study and interpret in detail the development of the flower garden and its meaning within the French Impressionist aesthetic, but as Robert Herbert has written: "The Impressionists represent flowers more often [than vegetable gardens and other rural uses of the land in the painting of the Barbizon-related painters] because, in effect, they were more citified . . . Essentially urban artists, most of the Impressionists, in the countryside, reacted to flowers and meadows more favorably than to pigs and brussel sprouts."[11]

Monet's garden pictures were, thus, one source of inspiration for native American explorations of this theme; another was the work of the American

expatriate, John Singer Sargent. Sargent's limited involvement with the garden picture began in 1884, when he left Paris in the wake of the scandal over the showing in that year's Salon exhibition of his *Portrait of Mme. Gautreau*, referred to as *Mme. G.*, and to become known as *Mme. X.*, or exhibited as *Mme. ***. Sargent went to England, where one of the portraits he painted for the Albert Vickers family, at whose home in Lavington he stayed in the summer of 1884, depicted the children, Vincent and Dorothy Vickers, amidst a field of lilies as prominent as the children themselves. The children are obviously meant to be identified with the flowers, which are emblems of purity, the figures immersed in an horizonless, undefined garden setting. This portrait study was a private work, of course, but Sargent in turn elaborated upon it in what was to become his most famous, and one of the best-received of his rare public exhibition pieces: *Carnation, Lily, Lily, Rose*.

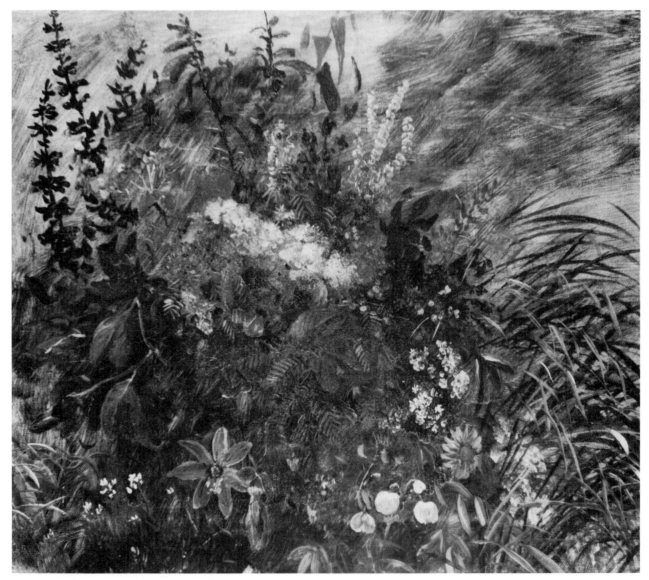

Frederic Edwin Church (1826–1900)
Jamaican Flowers, 1865

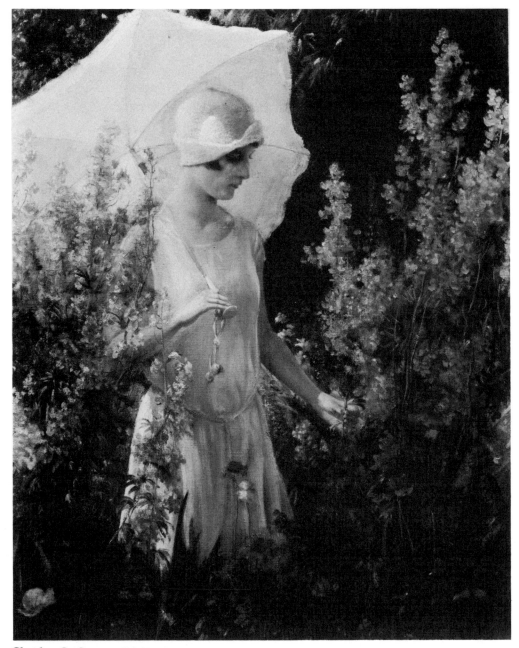

Charles C. Curran (1861–1942)
Delphiniums Blue

This painting was begun in the autumn of 1885, in Broadway in Worcester-
shire, in the garden of his friend and colleague, the American artist, Frank
Millet. The two daughters of the artist, Frederick Barnard, were his models,
standing amidst the lilies, roses, and carnations of a garden hung with Japa-
nese lanterns. With the end of the season, Sargent left the canvas incomplete
and returned to it the following summer when Millet had moved from Farn-
ham House to Russell House in Broadway. The artist Edwin Blashfield re-
called watching the painting develop, commenting upon the loveliness of the
Russell House gardens, and watching little Pollie and Dollie Barnard light the

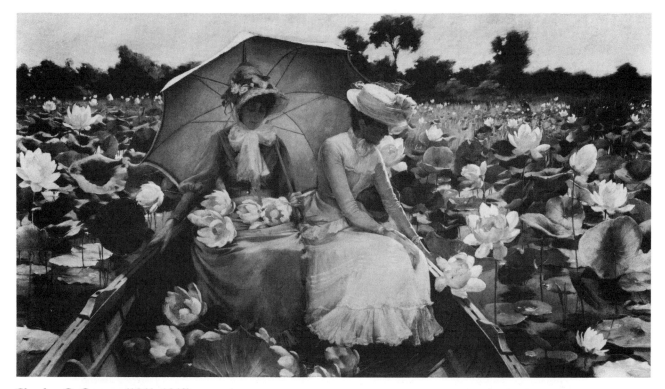

Charles C. Curran (1861–1942)
Lotus Lilies, 1888

lanterns among the tall stemmed lilies.[12] The iconography is similar to that of the Vickers children study, though the portrait identification was now submerged in an idyllic scene of childhood, and the painting is far more resonant of light and color. An Impressionist work, painted upon for only a brief period each evening over two seasons, it is Sargent's *modified* Impressionism of more controlled forms, muted color and evening light.

Lily Millet, the artist's wife, was an active gardener, although she was assisted by still another artist, Alfred Parsons. The Millet garden at Russell House was later to be known particularly for its roses and carnations; Mrs. Millet was known for her cultivation and hybridization of the latter.[13] In Sargent's time there and in his painting, it was obviously the lily that dominated and which attracted him most. This is confirmed by other paintings he did at the time, a number of far more freely painted, pure garden scenes, suffused in sunlight and among the most advanced painting to be practised in England at the time. No wonder that a critic in the *Art Journal* in 1887 referred to him as the "archapostle of the dab and spot school." Others of Sargent's paintings depict roses in garden and trellis settings, but it was *Carnation, Lily, Lily, Rose* that brought him immense celebrity. The painting's reception on its exhibition at the Royal Academy in London in 1887 must have increased the popularity of the garden picture, though it was the sentiment of the Botticellian angel-like young girls, rather than the excursion into a tempered Impressionism in the garden landscape, that especially attracted the critics.

Sargent's involvement with flower and garden painting, and even his investigation of the Impressionist aesthetic generally, was relatively brief, being contained in the second half of the decade of the 1880s. It was displaced by a

combined concentration upon society portraiture and mural painting. On the other hand, Monet, once permanently resident in Giverny in 1883, started to develop the increasingly extensive gardens which much of his art celebrates. He began to attract young American artists to the small town of Giverny, painters who increasingly fell under the spell of Impressionism, in general, and Monet's aesthetic in particular. One of the first of these Americans to summer there was John Leslie Breck, who went to Giverny in 1887 with Theodore Wendel, Willard Metcalf, Henry Fitch Taylor, Theodore Robinson, and the Canadian, William Blair Bruce.[14] Breck subsequently sent back to Boston a group of paintings which were exhibited in Lilla Cabot Perry's Boston studio. Hamlin Garland recalled these, ". . . each with its flare of primitive colors—reds, blues, and yellows, presenting 'Impressionism,' the latest word from Paris."[15] This was one of the earliest appearances in this country of American Impressionism, and it was very likely manifested in the garden picture. Over the subsequent decades many American artists had some contact with Monet; a number were to take studios in Giverny, and the garden picture thrived there at the hands of American artists.

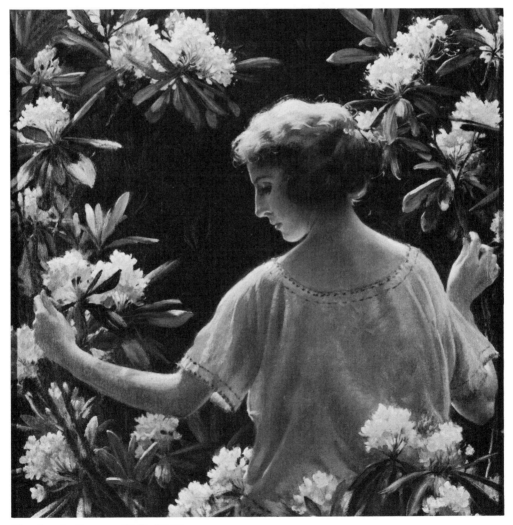

Charles C. Curran (1861–1942)
Rhododendron Bower, 1920

Gifford Beal (1879–1956)
The Garden Party, 1920

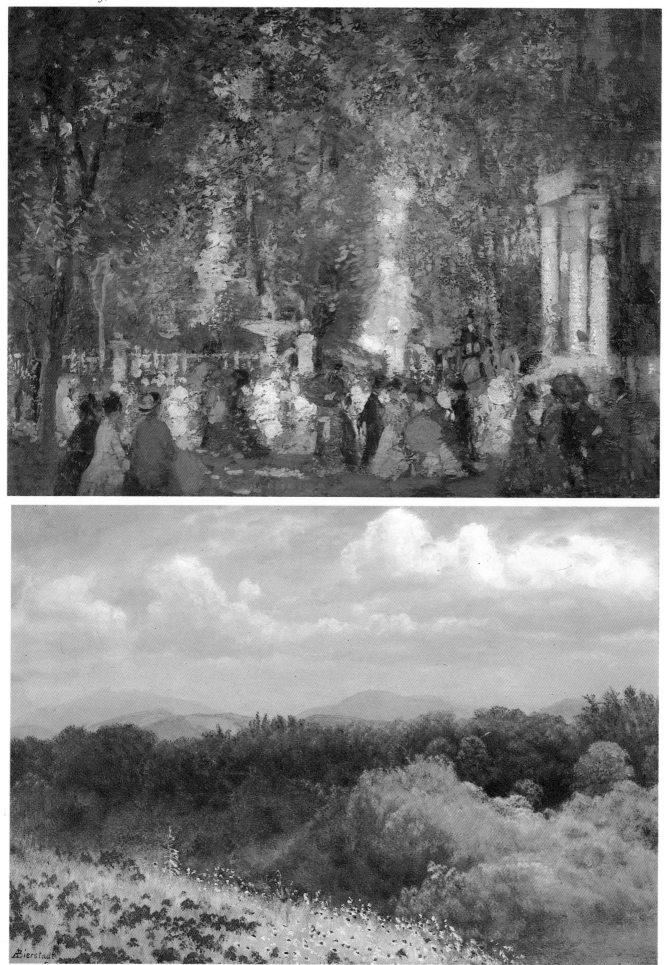

Albert Bierstadt (1830–1902)
Field of Red and Yellow Wildflowers

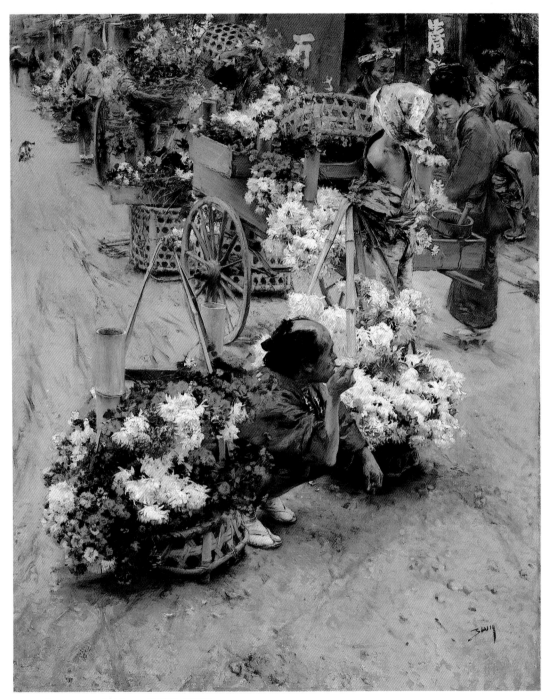

Robert Frederick Blum (1857–1903)
The Flower Market, Tokyo, ca. 1891

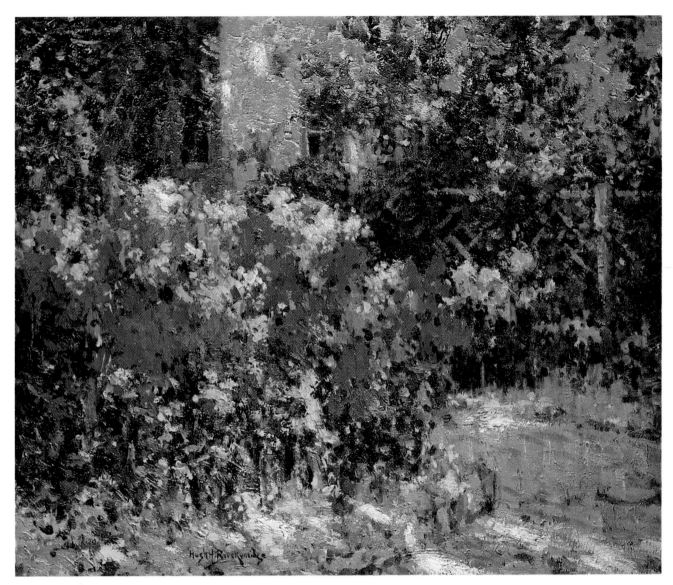

Hugh Henry Breckenridge (1870–1937)
The Flower Garden, 1906

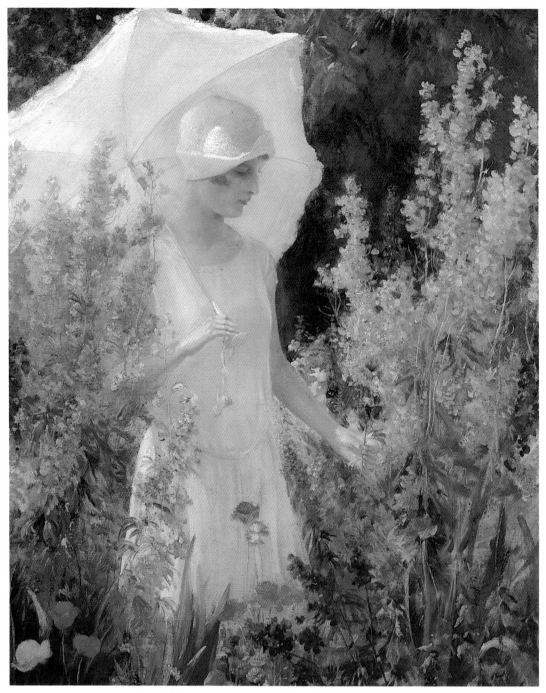

Charles C. Curran (1861–1942)
Delphiniums Blue

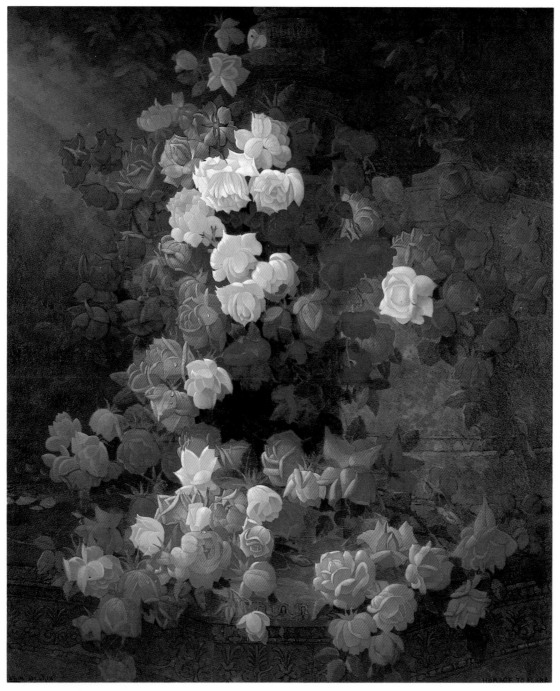

Edwin Deakin (1838–1923)
Homage to Flora, 1903–04

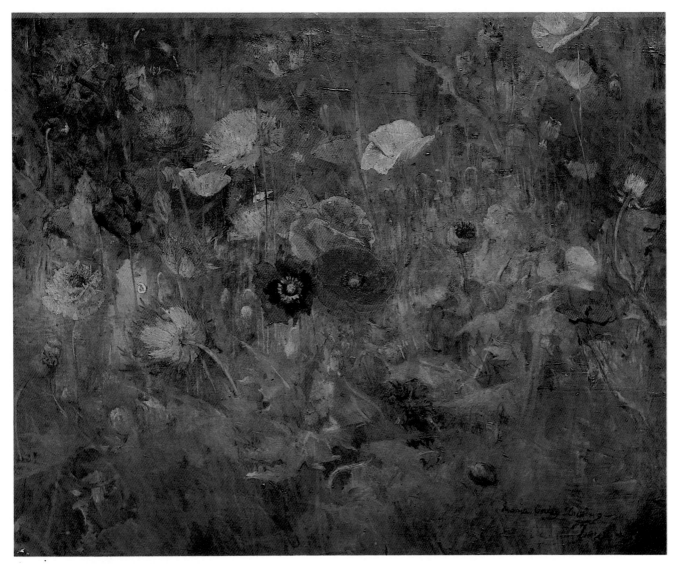

Maria Oakey Dewing (1857–1927)
Bed of Poppies, 1909

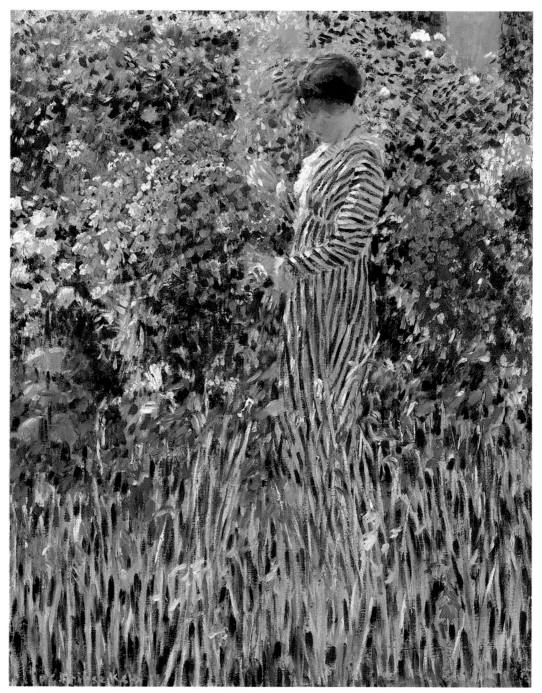

Frederick Carl Frieseke (1874–1939)
Lady in a Garden, ca. 1912

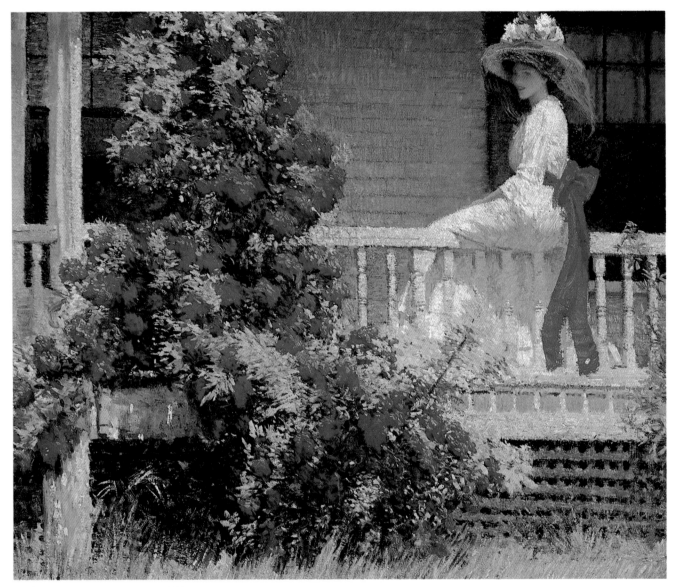

Philip Leslie Hale (1865–1931)
The Crimson Rambler

The most orthodox of the American Impressionists, Childe Hassam, does not appear to have had direct contact with Monet, but Hassam did become the foremost exponent of the garden picture, and the painting of the floral environment. An interest in flowers appears with a *Vase of Flowers*, in 1885. That, however, was a small, formal still life. It was two years later before he began to create garden pictures intensively, beginning in 1887, on his second, longer and more influential stay in France, and his concentration upon this theme lasted over a decade.

Hassam's interest in the exploration of the theme of the garden and the general floral environment coincides, not surprisingly, with his exposure to

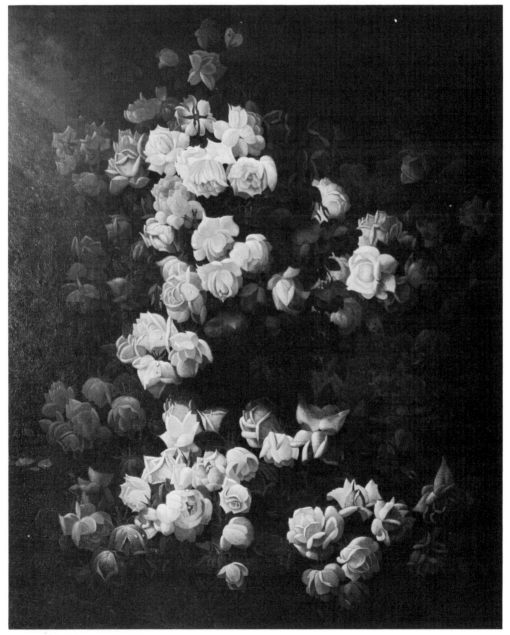

Edwin Deakin (1838–1923)
Homage to Flora, 1903–04

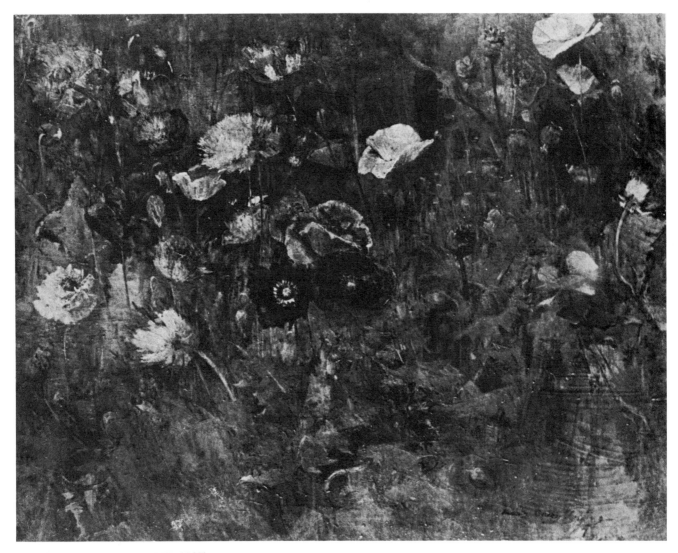

Maria Oakey Dewing (1857–1927)
Bed of Poppies, 1909

and his immersion in the Impressionist aesthetic, in which the theme had already been adopted by Monet and others; understandably, this occurred after Hassam returned to France in 1886. While not incorrect, this may be too facile an explanation for Hassam's new concerns. We are still too unclear of Hassam's interests and associations in his pre-Parisian (and pre-Impressionist) days back in Boston, other than our familiarity with his beautiful urban scenes of twilight and rainy Boston done in a Tonalist manner. For instance, his friendship with the once-popular watercolorist, Ross Turner, needs more elucidation. Turner and Hassam shared teaching classes, and worked together on illustration projects, and in his watercolor, *A Garden is a Sea of Flowers*, Turner demonstrates a fascination with the garden environment not dissimilar to Hassam's. This work, of course, painted on Appledore, where Hassam, as shall be noted, painted so many of his finest flower pictures, is a very late picture, and very likely depends upon Hassam's developed aesthetic, but it may well be that in his youth, Hassam was guided

and directed in some of his concerns by the older Turner. Turner, who evinced an interest in the work of Monet in the 1890s, was noted for his concern for the motif of the floral environment. As one critic wrote: "Gardens and growing flowers, ever favorite motives with this artist. . . ."[16] Likewise, Hassam's friendship with Abbott Graves needs further elucidation in this regard, since Graves was to become the outstanding Boston specialist of the garden subject, a theme he had begun to essay by 1886, the year his good friend Hassam returned to France.

Hassam's exposure to the French Impressionist garden picture need not have awaited his return to Paris, in fact. He was still in this country serving as an usher at Abbott Graves' wedding in October 1886, which allowed him the opportunity, therefore, to view the great exhibition of French Impressionist painting that Durand-Ruel mounted in New York City at the American Art Galleries in April of that year, a show so popular that it was extended, with additions, at the National Academy of Design. Forty-eight works by Monet were shown there, including another from the series of four Vetheuil garden paintings. Nor is it likely that Hassam would have overlooked this picture, since it was singled out in the most outstanding review of this show published

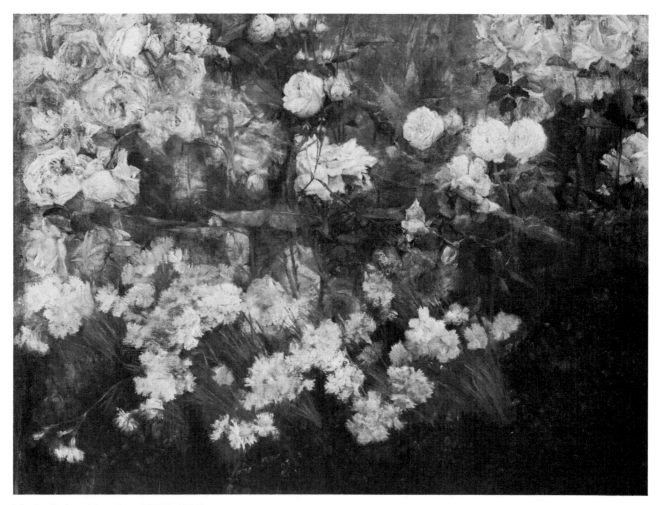

Maria Oakey Dewing (1857–1927)
Garden in May, 1895

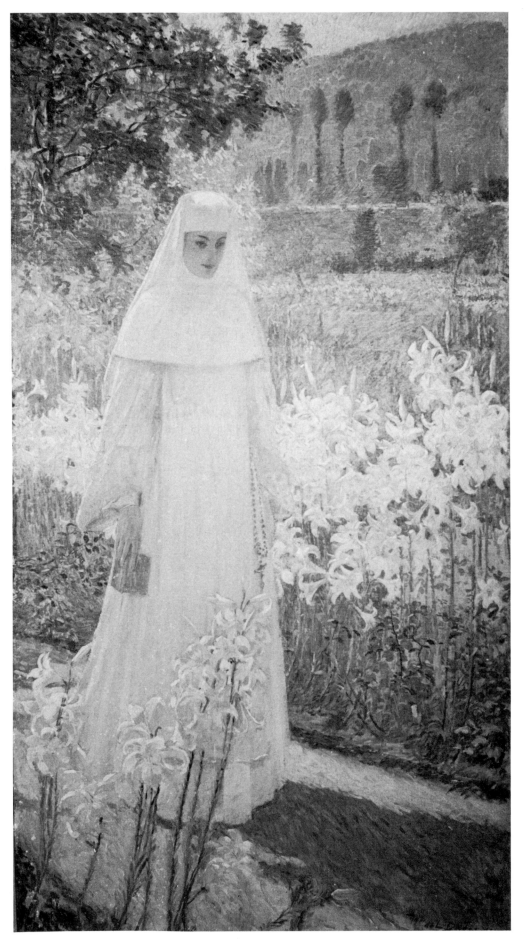

William Dodge (1867–1935)
Nun in Giverny Gardens

John J. Enneking (1841–1916)
Rose Garden, 1880

in English, and one of the most comprehensive treatments anywhere to date of Monet's art, particularly: that by Mrs. Helen Cecilia De Silver Michael, published under the pseudonym of Celin Sabbrin, and entitled *Science and Philosophy in Art*.[17]

Mrs. Michael marked the work as a cornerstone of her analysis of Monet's compositional and coloristic theory, which she referred to as the theory of triangulation. A detailed analysis and discussion of this conception is beyond the purposes of this essay, but it is not totally irrelevant, for, as the term implies, she noted a profound and quite rigorous geometric structure under-

lying Monet's compositions, including this picture of Monet's *Garden at Vetheuil*. After analyzing the color and space, she summed up its impression as ". . . one of warmth and vitality. Rich tones of green, blue, red and orange are used with wondrous skill. It is a mid-summer scene; the vegetation is at its highest; the air sultry and heavy with heat. It is a picture of the present moment. . . ."[18]

Within the year, Hassam was in Monet's homeland, to study at the Académie Julian. We are ignorant of the circumstances of his attraction to more avant-garde art, but an awareness of, and enthusiasm for, Impres-

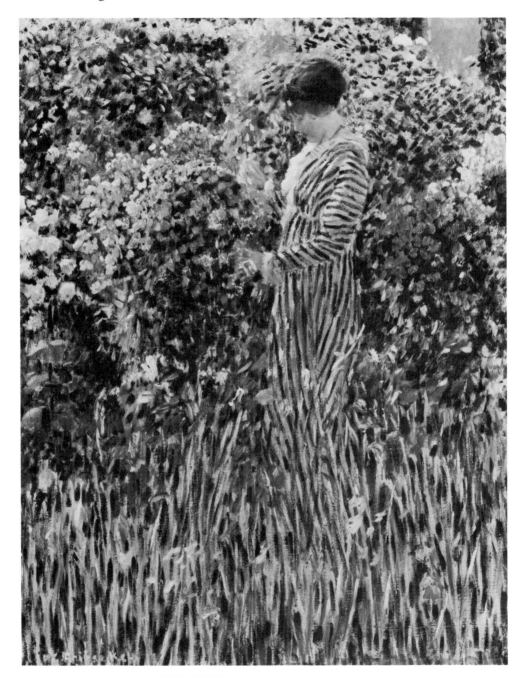

Frederick Carl Frieseke (1874–1939)
Lady in a Garden, ca. 1912

Edmund Greacen (1877–1949)
Spring Garden

sionism is demonstrated in such pictures of 1887 as his famour *Jour du Grand Prix*. It is also confirmed in the earliest located of his garden pictures, *The Garden at Villiers-le-Bel* (Cartwright collection, Marshalltown, Iowa) of the same year. Hassam and his wife had become friendly with a family who had a home in that small town of Villiers-le-Bel, north of Paris, and summered there. He would undoubtedly have known that the area had been an artistic center in the previous generation, for the great artist and teacher, Thomas Couture, had spent his last decade there, from 1869, when he had many American pupils, and the very popular and influential Edouard Frère was installed nearby at Ecouen.

Hassam does not appear to have explored the countryside around Villiers-le-Bel in the late 1880s but rather, when not in Paris, to have concentrated upon garden pictures, such as *The Flower Garden* of 1888. This example, particularly, is not only similar to Monet's Vetheuil garden pictures in its vertical

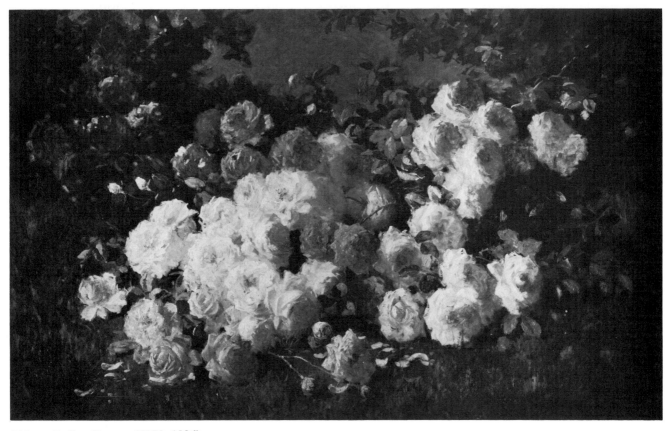

Abbott Fuller Graves (1859–1936)
Pink and Red Roses

format and general backyard garden subject, but despite a more restricted and
darker color range, it shares a not dissimilar geometric grid structure. The
rigid upright of the vertical figure of the young woman in white is central to
the receding parallelogram of the garden path, and this is flanked by rhom-
boidal banks of vegetation. Here, and to a lesser extent, in other pictures of
these years such as *A Sunny Morning, Villiers-le-Bel* of 1888, and *Mrs. Hassam in
Their Garden*, Hassam appears almost to have taken Mrs. Michael's analyses of
Monet's art to heart.

At the same time, Hassam has constructed a garden image of traditional
beauty: the lovely young woman among the flowers, picking a bouquet of
some, with others in a garden container and still more alive and growing, all
amidst the dappled sunlight. Hassam's color range is somewhat restricted, so
that the virginal white of the young woman stands out more strongly against
the richer tones of the foliage, and she is, again, in an enclosed garden, an
enveloping symbol at once of beauty and protection. Others of these garden
pictures depict his wife, the former Kathleen Maude Doane, comfortably re-
laxing in the garden. Sometimes she is central to the composition and the
potted flowers peripheral. In Hassam's *Reading* of 1888, the flowers and
Maude Hassam share equal prominence—an obvious identification of
loveliness and domestic ease. Other times, as in his *Geraniums* of the same
year, the potted flowers on a stepped structure surround the image of his

beloved, who appears only in the background, amidst the blooms. Here, too, the sense of geometric structure is very strong for all the gaiety of the colorful flowers.

Hassam was not the only American to paint such French garden scenes in the '80s. The more academically-oriented Abraham Archibald Anderson painted a young woman painting a landscape amidst potted and naturally growing clumps of flowers in *French Cottage* in 1883, all silhouetted against a flat, reflective backyard wall in bright sunlight, again an image of ease and relaxation, though the figure here is more active and, of course, more art-involved. And the later *Flower Pots on the Terrace* by Sargent's friend, Edward Darley Boit, referred to by one critic as "that cleverest of our impressionist

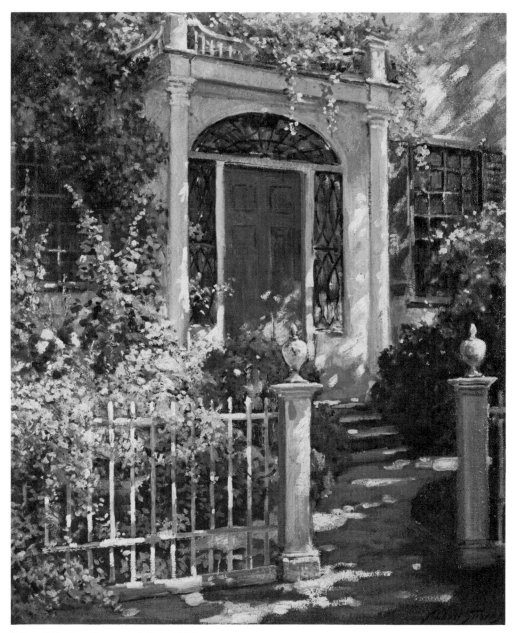

Abbott Fuller Graves (1859–1936)
Portsmouth Doorway, ca. 1910

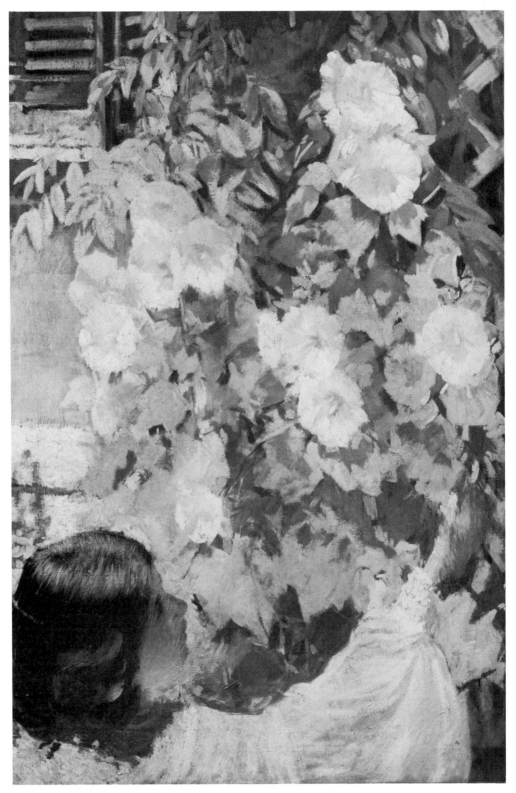

Philip Leslie Hale (1865–1931)
Hollyhocks

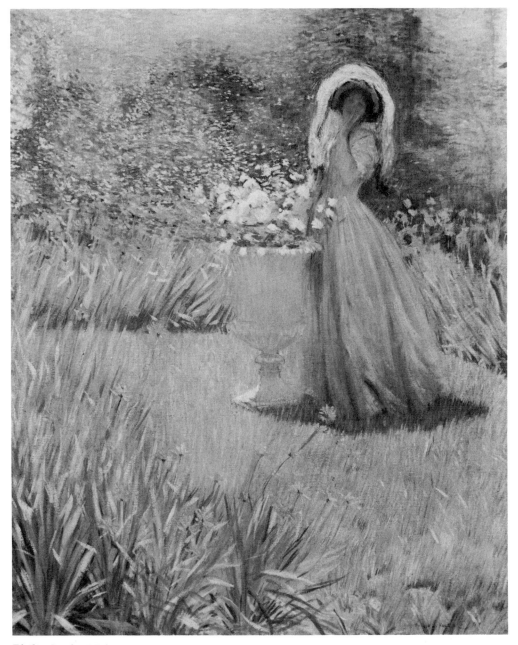

Philip Leslie Hale (1865–1931)
In the Garden

water-colorists," projects a similar sentiment of informal, pleasant domesticity in a sparkling ledge of potted plants, even without the presence of figures. Paintings of cultivated gardens appear less frequently in Hassam's oeuvre after he and his wife returned home late in 1889, and correspondingly, he returned to the painting of planned, somewhat formalized flower gardens when he went back to Europe late in 1896. After the work of this trip, done in France, the garden picture seems to appear only sporadically in Hassam's art.

Allied to the garden picture, but expressive of a somewhat contrasting attitude toward nature, and evolving from a more purely landscape mode rather than related to the still-life tradition, was the field carpeted in flowers,

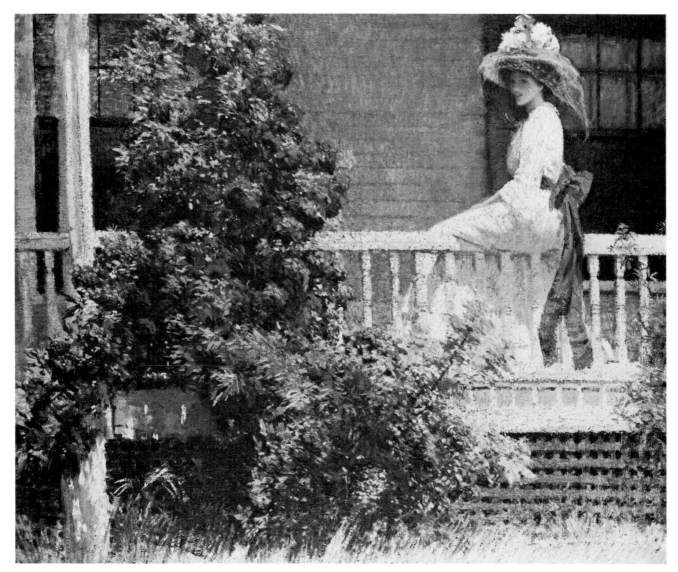

Philip Leslie Hale (1865–1931)
The Crimson Rambler

sometimes contained, sometimes expansive. This motif began to be depicted prominently at the same time that the renaissance of the flower garden appeared, in the 1870s. This may well be the period that Albert Bierstadt painted the aforementioned *Field of Red and Yellow Wildflowers*, though generally the American manifestations of this motif were produced some years after they began to appear in considerable numbers in Europe. There the emergence of the pictorial flower field was international. As with the garden motif, the field might be totally unpopulated, or, more often it might be used as a foil for the presentation of relaxed figures, at ease, sometimes communing with nature, sometimes at play, or immersed among the flowers and occasionally making bouquets of them.

Pinpointing the earliest manifestation of the field of wildflowers is irrelevant to the present discussion, but it begins to be seen in depth in European art, and displayed in ambitious works, in the early 1870s. In Germany, one of

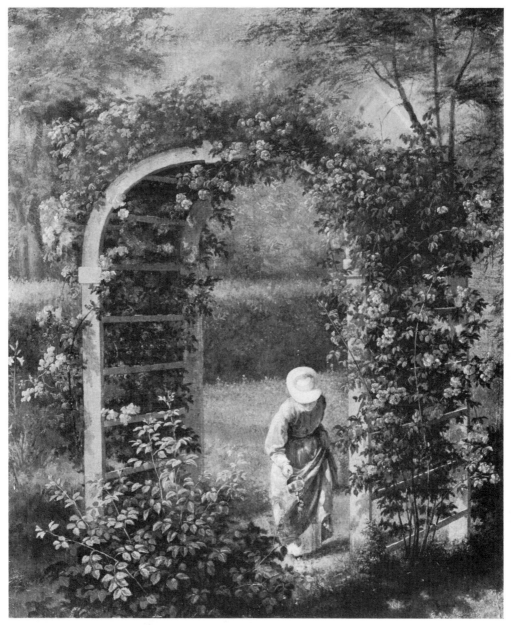

Jeremiah Hardy (1800–1888)
The Hardy Backyard in Bangor of 1855

the artists, who investigated it with obvious relish was Hans Thoma, as in his *Summer* of 1872 or *The Rhine Near Sackingen* of the following year. The former displays a lighthearted playfulness akin to the work of Arnold Böcklin, as in the latter's *Flora Strewing Flowers* of 1875; the latter is a more serious work, despite the carpet of wildflowers in the foreground, with peasant figures at once related to Millet's art but iconographically suggestive of a Flight into Egypt (though the gay flower field considerably relieves the weighty mood of either source). Of the same time, too, is that masterpiece of Hungarian Proto-Impressionism, Pal Szinyei Merse's *Picnic in May* of 1873, a thoroughly modern, unsentimental view of a group of young and attractive urbanites enjoying a country outing amidst a brilliantly colored field of wild flowers.

A fairly significant date in this regard may be 1873. It is the year of some of Claude Monet's earliest ventures into the painting of the uncultivated flower field, and also introduces the flower with which he, and many of those who followed him, became primarily associated—the poppy. Monet's 1873 *Poppies at Argenteuil* was exhibited the following year in the first Impressionist exhibition at Nadar's studio, and while the picture was not particularly noticed by the critics, it did, in turn, inspire other French artists such as Charles Daubigny in his *Fields in the Month of June* of 1874, a work criticized by his

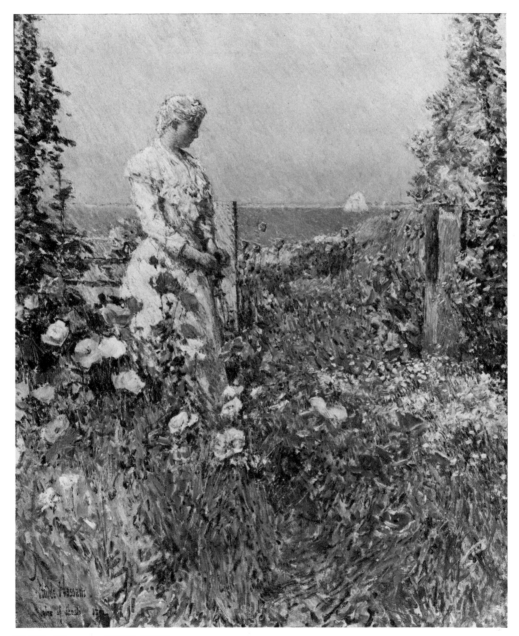

Childe Hassam (1859–1935)
Celia Thaxter in Her Garden, 1892

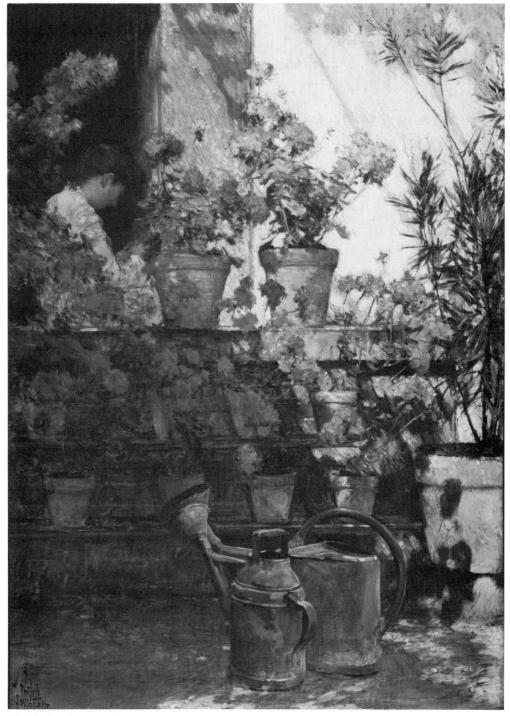

Childe Hassam (1859–1935)
Geraniums, 1888–89

colleague, Corot, as "blinding."[19] Monet painted several pictures of poppy fields near Vetheuil at the end of the decade, but the motif came into prominence in his art particularly after his move to Giverny in 1883, with his production of a whole group of poppy paintings in 1885, followed by others later in the '80s and another large number of them in 1890.

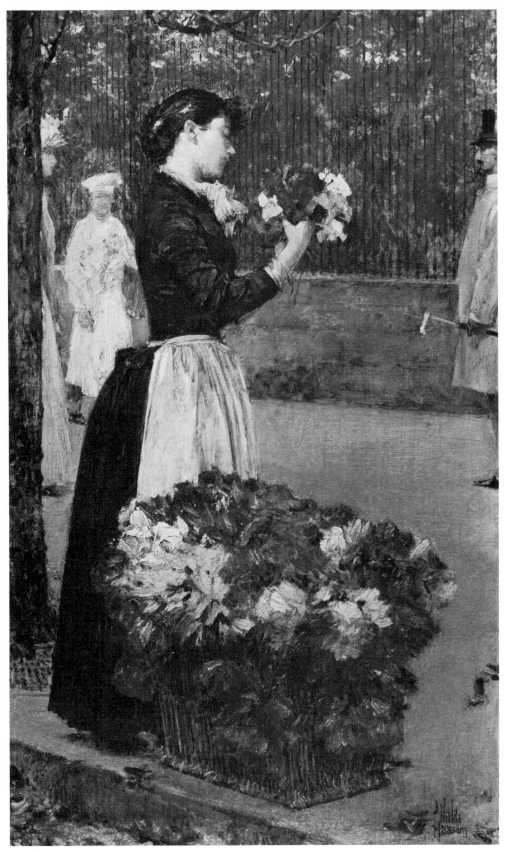

Childe Hassam (1859–1935)
Flower Girl, ca. 1887–89

The inspiration of Monet in regard to this motif continued, as in the work of Georges Seurat. That influence was felt in America also, and it would appear, quite quickly and directly. It has already been pointed out that one of Monet's Vetheuil garden pictures elicited much comment and praise in Helen De Silver Michael's pamphlet of 1886, reviewing the Durand-Ruel Impressionist

Childe Hassam (1859–1935)
Home of the Hummingbird, 1893

Childe Hassam (1859–1935)
The Isle of Shoals Garden, ca. 1892

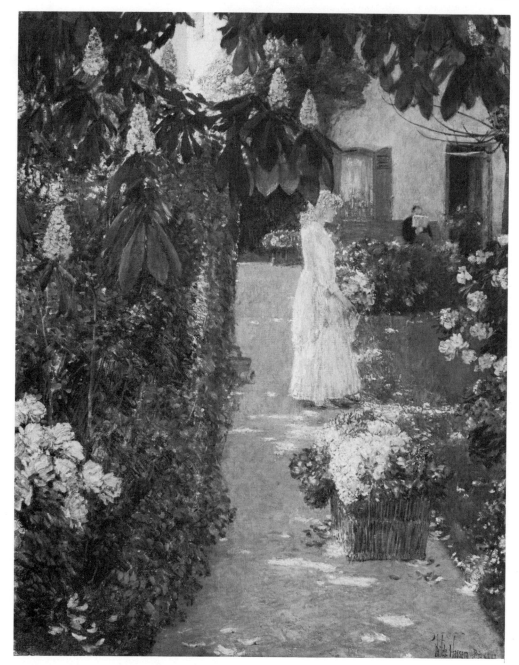

Childe Hassam (1859–1935)
Gathering Flowers in a French Garden,
 1888

exhibition in New York. But while dealing with many of Monet's works in her review, Mrs. Michael reserved her greatest attention for two of the artist's pictures of fields of poppies: *Poppies in Bloom* and *Landscape at Giverny.*

Mrs. Michael's analyses of these paintings, as, indeed, of all the works in the show by Monet, did not treat them in the usual terms of spontaneity and carefree pleasure. She did not see Monet as did Cézanne—as an eye, but what an eye! Rather, as she said about these works, "As art expressions of scientific and philosophical thought, these two pictures occupy the most prominent

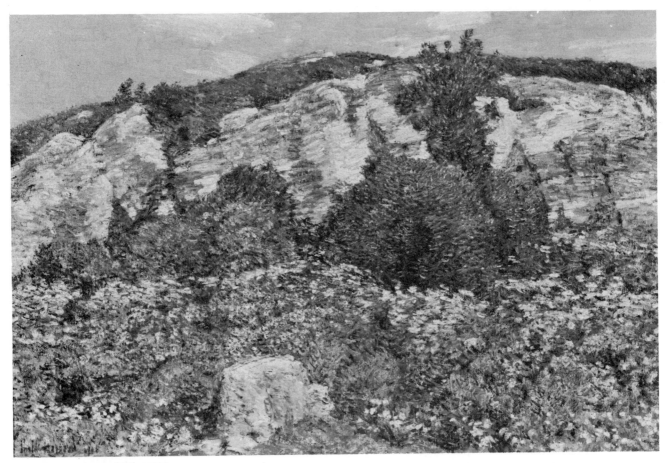

Childe Hassam (1859–1935)
Laurel in the Ledges, 1906

place of any in the collection."[20] One may today look with some skepticism on Mrs. Michael's reversal of traditional philosophical values in her understanding of Monet's art, when she saw these poppy pictures as

> . . . an expression of hopelessness, of the unattainableness of absolute truth, and a confirmation of science's teachings, in the ultimate uselessness of human effort. Speculation can go no further; what is beyond these hills may never be known. The heart weakens and the soul is faint at what she sees. It is the end of the struggle of the human race; all work and thought have been to no avail. The fight is over and inorganic forces proclaim their victory. The scene is a striking reality. Nature is indifferent, and her aspects are meaningless, for what indications of the unavoidable end come from seeing that gay flowered field? It is a mockery, and that mind which has once felt the depth of the thoughts expressed in this painting, can only seek safety in forgetfulness. Monet does not offer any solution to the result to which his pictures lead. He is occupied in giving expression to the most serious truths of our life. He is recording the chronicle of modern thought.[21]

Until recently, such an interpretation of nihilism and despair in Monet's paintings of the 1880s would have been interpreted as idiosyncratic and ec-

centric in the extreme. Today perhaps, with a fuller understanding of the interaction between Monet's art and the course of his life, both material and psychical, as reflected for instance in the rugged and wild Belle Isle and Creuse landscapes, also of the '80s, Mrs. Michael's writings deserve renewed attention.[22] In any case, *Poppies in Bloom* also served for Mrs. Michael as "the best illustration of the theory of triangulation to be found in Monet's pictures." However controversial may be Mrs. Michael's psychological analyses of Monet's art, her perceptions of the formal compositional structure of his work deserves respect and study. As Steven Z. Levine has noted, she "saw Monet's art as an attempt to analyze the complexity of appearance into its constituent elements by means of a rigorously geometrical organization of the forms of nature," and "developed an iconography of recurrent geometrical forms and forces such as parallel diagonals, right-angle triangles, dissymmetrically framed, bilaterally symmetrical reflections, etc."[23] Of *Poppies in Bloom*, for instance, Mrs. Michael noted that the field itself was structured as a parallelogram, and that the whole picture appeared as the interior of a geometric solid, empty of human activity, and indeed, it was the soullessness of geometry that resulted in the pitilessness of the natural forces depicted.[24]

Mrs. Michael was not alone in emphasizing the impression made upon American critics and writers by the poppy pictures in the Impressionist show. Mariana Van Rensselaer, for instance, writing in *The Independent*, said that "the valley of poppies may look exaggerated to American eyes, but is simply and delightfully truthful to those who have seen French or Belgian or German fields in early summer."[25] And even to those Americans who took a deeply negative view of the new art form of Impressionism, in general, and toward Monet's art, in particular, such as the conservative artist and writer F. Hop-

Childe Hassam (1859–1935)
Poppies, Isles of Shoals, 1890

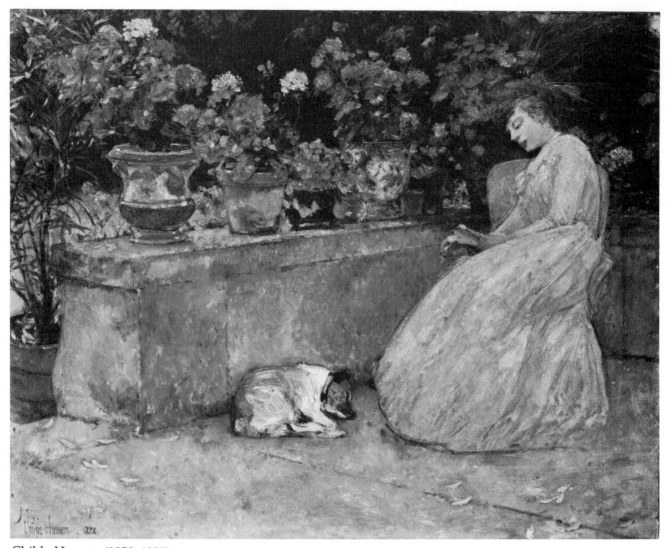

Childe Hassam (1859–1935)
Reading

kinson Smith, these works at least required special notice. In a lecture before
the Rembrandt Club in Brooklyn in 1888, after satirizing a painting of ballet
dancers by Degas, Smith went on to discuss another Impressionist who
"throws a tomato salad at a canvas and calls it 'Poppies in Bloom.' Then he
picks out the tomatoes, and leaving the yellow mayonnaise, calls it a
'wheatfield'. . ."[26]

American patrons of contemporary art, too, were impressed by Monet's
poppy pictures. *Poppies in Bloom,* for instance, was acquired by the notable
collector Albert Spencer; it was subsequently on exhibition again in New York
City, at the Union League Club, in 1891. Its companion, the *Landscape at
Giverny,* was purchased from the 1886 New York show by Alden Weyman
Kingman, a major holder of Monet's work. *A Poppy Field* by Monet was men-
tioned by *The Collector* magazine as exhibited in the One Hundred Master-
pieces exhibiton held at Copley Hall in Boston in March of 1897, lent by Mrs.
David P. Kimball, but that may be a titular confusion with the *Poplars near
Argenteuil* of 1875 owned by Mrs. Kimball.

Monet's paintings of fields of flowers continued to have an influence upon younger European artists drawn to the Impressionist aesthetic. Georges Seurat, for instance, investigated the theme around 1885, in his *La Luzerne in Saint-Denis*. But the impact of such work may have been even greater upon American artists, particularly those beginning to work within the Impressionist aesthetic both at home and abroad, starting in the second half of the 1880s, immediately after the Durand-Ruel show in New York City.

One of the earliest of these was Robert Vonnoh, who had grown up in Boston and went to Paris to study in 1881. He was back in Boston, probably by late 1883 and subsequently taught at the Cowles School there, and then at the school of the Museum of Fine Arts, but returned to France in the summer of 1887. Much of his time was spent painting at Grez-sur-Loing, an artists' colony near the Forest of Fontainebleau, and by the following year he had begun to paint studies of poppies and other field flowers which would certainly constitute among the most advanced of American Impressionist works. In

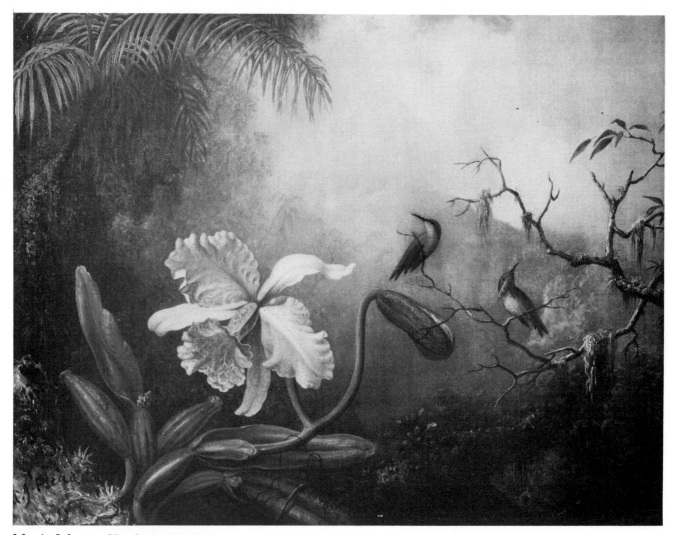

Martin Johnson Heade (1819–1904)
Cattleya Orchid with Two Hummingbirds,
 ca. 1880's

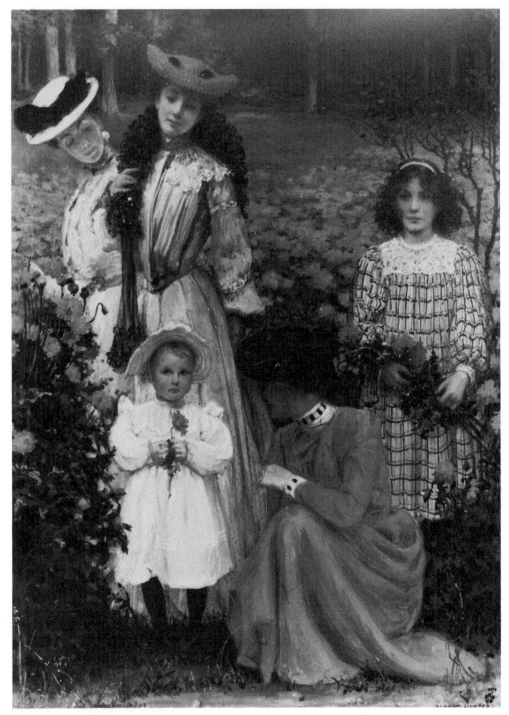

Albert Herter (1871–1950)
The Herter Family in Paris, ca. 1898

these works, Vonnoh plunges the spectator directly into the fields of flowers, into a maze of brilliant scarlets and chrome yellow, and with few spatial guideposts for orientation. Vonnoh was quite conscious of his alliance with the Impressionist movement, and noted that he had come to realize the value of the first impression and of pure color in a higher key,[27] though Grez, unlike

Giverny, had not yet become a center of Impressionist painting, and Vonnoh claimed to have seen Monet's work only in 1889.

These small studies of field flowers—primarily the poppy—served in turn as preliminary studies for one of the artist's major works, his *Coquelicots* (Poppies) shown at the Paris Salon of 1891, and in Munich the following year. Unlike the preliminary studies, the composition is a well-ordered and organized rural landscape showing a lovely lady and several children picking the scarlet blooms in a sun-drenched field, while in the distance is a farm wagon, with farm buildings behind. Vonnoh has retained the brilliant colorism and spontaneous brushwork of his studies, but these are here applied to a studio

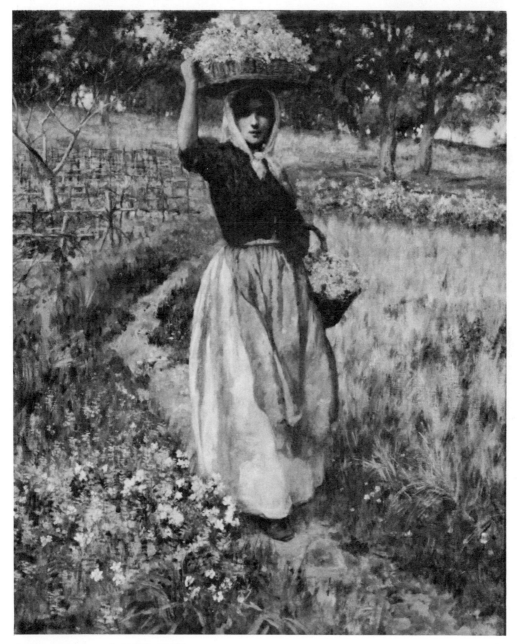

George Hitchcock (1850–1913)
The Flower Seller

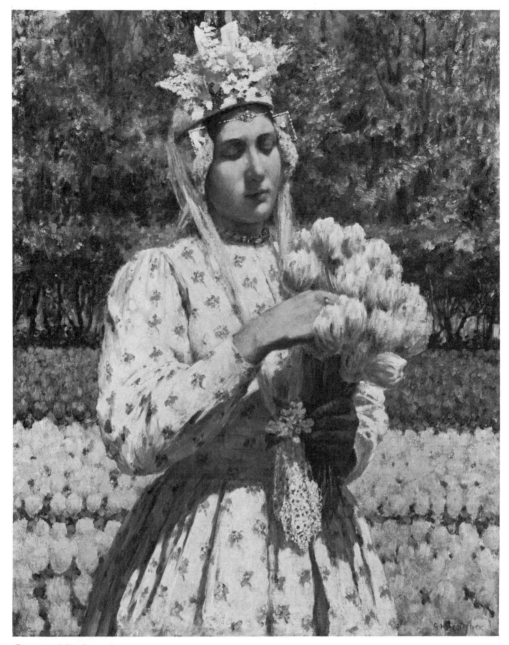

George Hitchcock (1850–1913)
In Brabant

composition. While it would almost surely be a misconception to apply Mrs. Michael's theory of triangulation observed in Monet's poppy fields to Vonnoh's *magnum opus*, there is here a strong sense of geometric structure, though Vonnoh has in some ways disguised it within the painting's overall spontaneity. The flowers are patterned in the foreground along a repeated diagonal, reinforced by the pose and posture of the young woman, while the middle ground begins with rows of poppies parallel to the picture plane. The beginning of this middle area is marked by a greener section in which the children are posted, and ends with a row of tall trees, separating it from the

distant farm buildings. This structuring, moreover, is effective both two- and three-dimensionally.[28]

Vonnoh's *Coquelicots* is certainly one of the most significant and monumental American statements concerning the harmonious identification of Man, or rather woman and children, and Nature, within the late nineteenth century Impressionist aesthetic. Nature is open but tamed, and the human posture within is graceful rather than rugged. The figures all partake of the beauty of nature, even while contributing to it; this is Nature domesticated. A fellow painter, Charles C. Curran, in an article on "The Outdoor Painting of Flowers" in 1908, began by describing another picture of Vonnoh's entitled *Spring-*

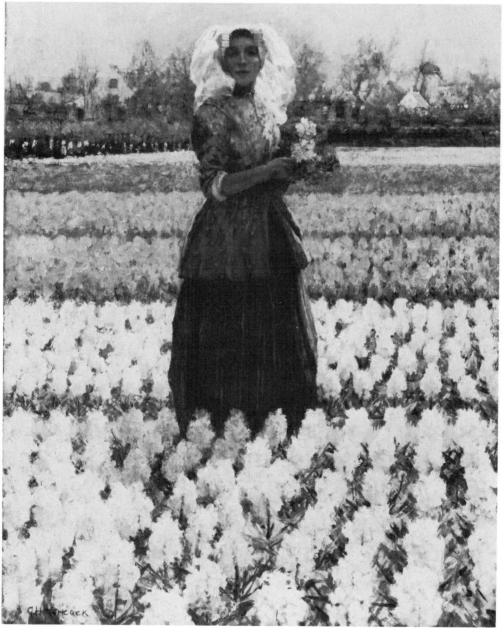

George Hitchcock (1850–1913)
Lady in a Field of Hyacinths

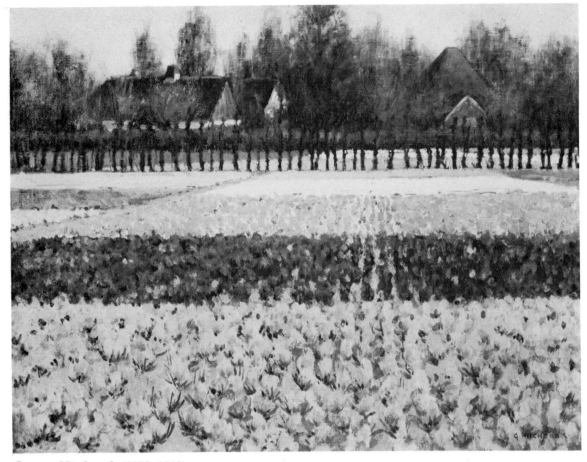

George Hitchcock (1850–1913)
Spring Near Egmond

time, and by stating that "There is implanted in the soul of man an instinctive
love for women, children and flowers, so that in considering this subject of
Flower Painting under the full light of day we are getting down to the funda-
mentals. What normal human being can see a garden full of flowers in bloom
or a hillside sprinkled with nature's own decorations, the wild flowers, with-
out an emotion of joyful admiration! What, therefore, can be a better subject
for a painter than that afforded by almost any village or country garden,
pasture or hillside?"[29]

Indeed, as a writer in 1908 noted, "This combination of flowers with women
and children is a favorite subject of Mr. Curran. . . ." The author went on to
say that "He is not the only painter who has been attracted by the flower-like
beauty of little children. Mr. John S. Sargent presents a similar theme in his
beautiful picture 'Carnation, Lily, Lily, Rose,' " and that "Mr. Childe Hassam
has given us glowing masses of light and color from midsummer gardens."[30]

It has already been pointed out that Hassam was an early and significant
delineator of the garden subject but he was, in fact, one of the major figures in
the depiction of the floral environment generally, flower gardens and fields of
flowers, or in some of his finest painting, where this distinction between the
two sub-themes is more or less obliterated. Hassam would of course have had
the opportunity of viewing Monet's paintings of fields of poppies in the

Durand-Ruel show, if he had not seen similar works in Paris. Hassam worked alongside Robert Vonnoh at the Académie Julian during the second Parisian stay of both artists, in 1887, so it is not improbable that Hassam was aware of Vonnoh's excursions into the painting of poppy fields the following year, as well as his two-year effort on the large *Coquelicots*, 1889–90.

After his return to America in the fall of 1889, Hassam resumed spending his summers on Appledore, among the Isles of Shoals, off the coasts of New Hampshire and Maine. He had probably begun spending time there in 1884, the year of his marriage. Besides the natural beauty of Appledore and its service as a retreat from the demands of studio life in urban centers, first Boston and then New York, the focus of the attraction of Appledore was the poet and writer Celia Thaxter. Mrs. Thaxter sponsored a kind of literary and artistic salon at her home, attracting New England artists such as Hassam, J. Appleton Brown, Arthur Quartley and—tragically—William Morris Hunt, who drowned there in 1879.[31]

Celia Thaxter's renowned garden on Appledore figured prominently as an

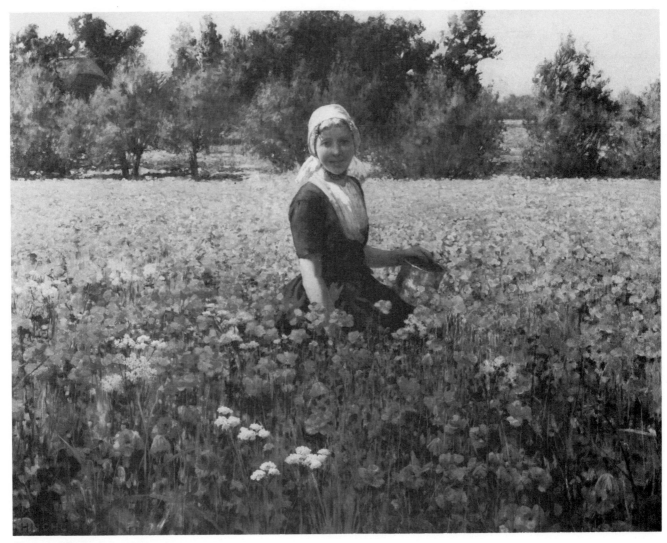

George Hitchcock (1850–1913)
The Poppy Field

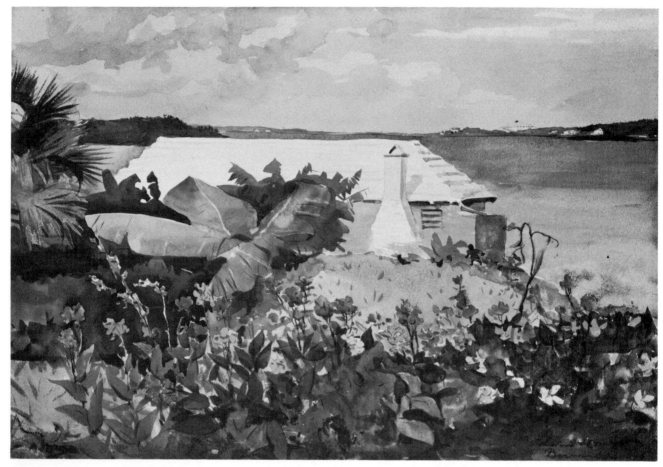

Winslow Homer (1836–1910)
Flower Garden and Bungalow, Bermuda

attraction for her artist-visitors from the start, for the first recorded artist there was Mrs. Thaxter's good friend, the watercolor flower painter, Ellen Robbins, who began visiting Appledore as early as 1850. Robbins' reminiscences contain a moving and affectionate picture of Celia Thaxter and her devotion to her garden.[32] That garden was the special joy of Thaxter, who celebrated it in prose and poetry, and her concern for her garden was recognized and admired by many of her visitors. Mrs. Emma Anderson, in a tribute to Thaxter, wrote: "Celia Thaxter's knowledge of flowers was one of her best known characteristics, and the trouble she took to make her garden on that rocky bed may well encourage some of us in our effort at floriculture. How can I ever describe this wonderful patch of color? I have not Ross Turner's brush, nor one of his pictures to show you. At first, the garden was started entirely for pleasure, but in after years it became quite a source of revenue, as the hotel guests gladly availed themselves of the privilege to possess the lovely corsage bouquets arranged by her own hands."[33]

Childe Hassam continued to summer with his family on Appledore well into the twentieth century, but his greatest tribute to and recognition of Celia Thaxter's garden is to be found in the group of paintings in varied media that he created between 1890 and Thaxter's untimely death in 1894.

Mrs. Thaxter's garden was, then, a cultivated garden, one in which poppies figured prominently. Yet strangely, in many of his Appledore poppy pictures, Hassam rather carefully suggests an uncultivated appearance, with the rich, random blooms in brilliant red appearing as a marvellous blaze of color against the foil of the white cliffs and the blue sea and sky beyond. Surely his point of view, and the approach that he adopts here were not chosen to negate the creativity of Mrs. Thaxter's expert gardening, but rather to suggest the wilder freedom of pure nature, the luxuriance of unfettered existence and a reflection of joyous exuberance which characterizes so much of the American response to Impressionism. These pictures also mimic the poppy pictures of Monet which had made a considerable impression in America only a few years earlier.

Hassam's Appledore pictures of 1890 and after also reflect the geometric compositional underpinnings that Mrs. Michael discovered in Monet's work, albeit less rigorously, less classically. Instead, in this group of works, Hassam concentrates more upon a sense of place, the New England shore and the

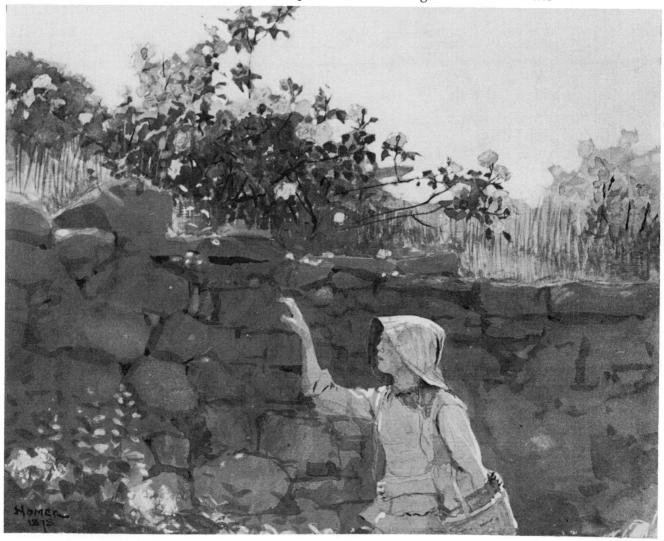

Winslow Homer (1836–1910)
Girl in a Garden, 1878

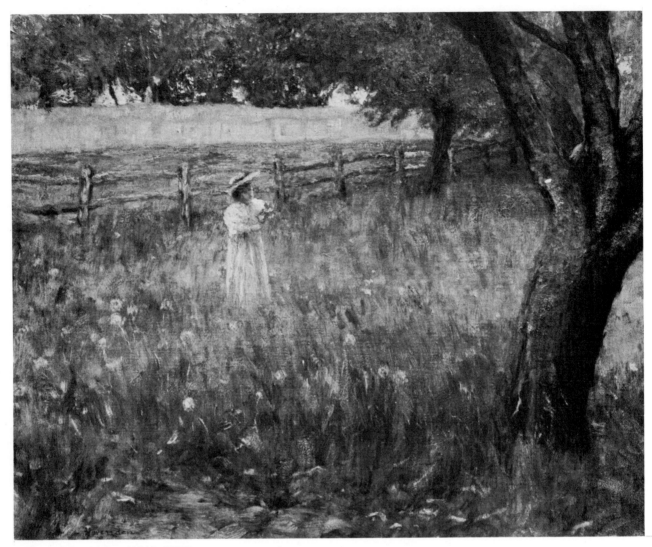

Thomas Hovenden (1840–1895)
Springtime, ca. 1892

group of islands of which Appledore was one, an identification with the topography which Monet, as Mrs. Michael suggested, had discarded. The poppies and other flowers dance in sunlight in the foreground, while the coves and shoreline of Appledore, and the irregular outlines of the outlying islands and distant coast beyond, are delineated in the background. Hassam's rugged, impastoed paint texture suggests equally the riot of color of the flowers and the granular texture of the rocky coast. In Hassam's pastel of *Poppies, Isles of Shoals*, also of 1890, the artist exploits the sketchy, chalky nature of this newly favored medium, while allowing the brown paper support itself to function as an earth layer from which the blooms grow; again the yellows, greens and vermillions glow brilliantly against the monochrome background. Hassam had just this year begun exhibiting with the organization, the Painters in Pastel, in their fourth and, unfortunately, last group exhibition.

The seemingly random appearance of Celia Thaxter's garden reflects her own floricultural predilections and those of her age; it was, as shall be seen,

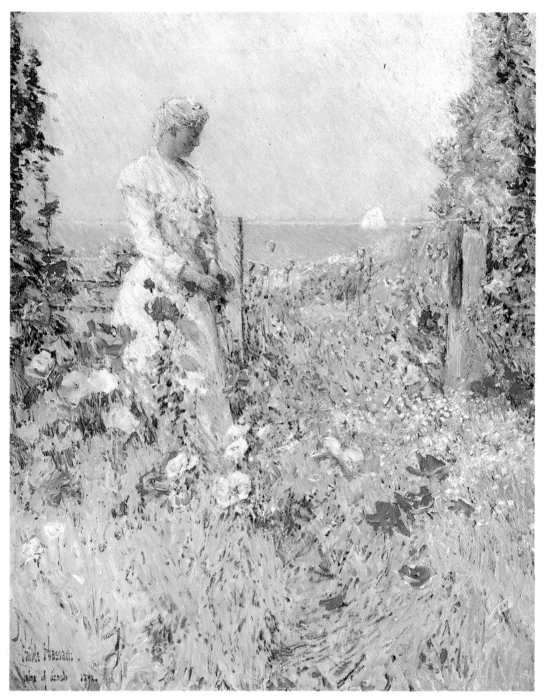

Childe Hassam (1859–1935)
Celia Thaxter in Her Garden, 1892

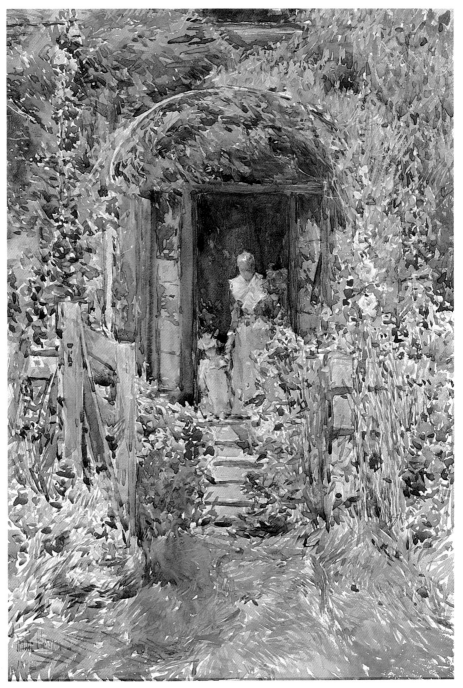

Childe Hassam (1859–1935)
The Isle of Shoals Garden, ca. 1892

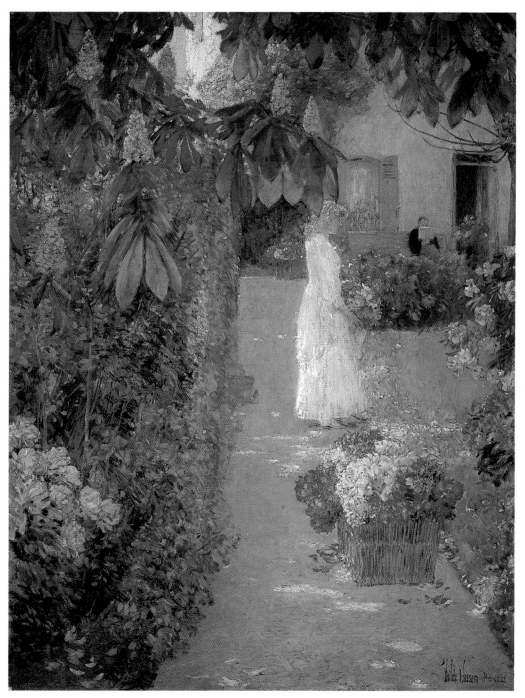

Childe Hassam (1859–1935)
Gathering Flowers in a French Garden,
 1888

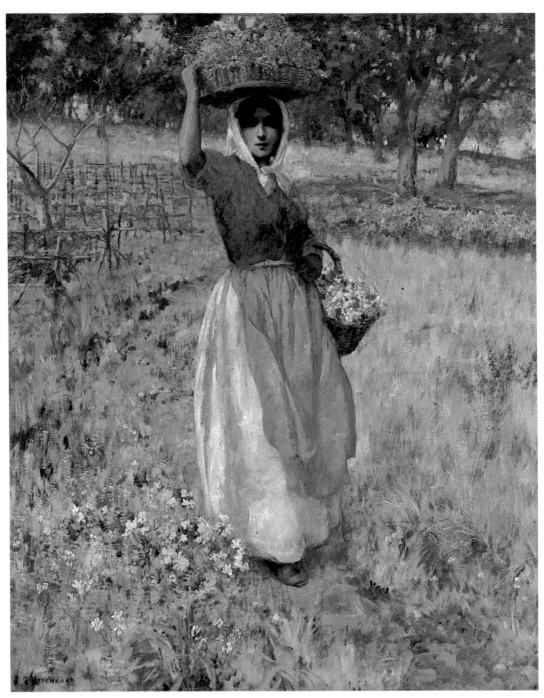

George Hitchcock (1850–1913)
The Flower Seller

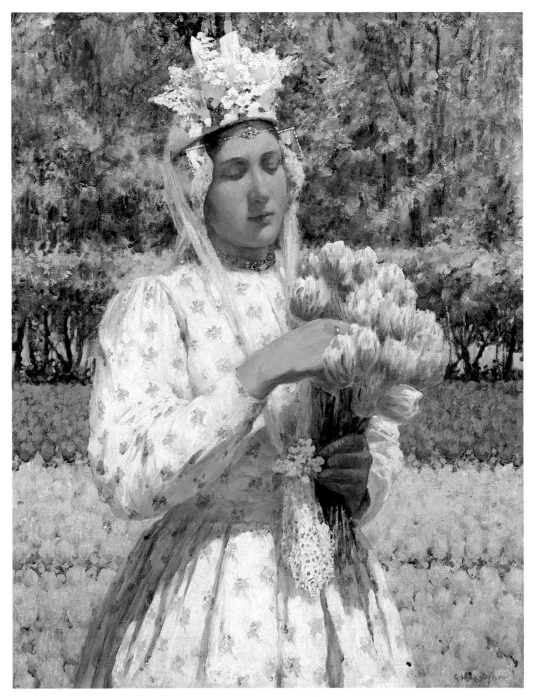

George Hitchcock (1850–1913)
In Brabant

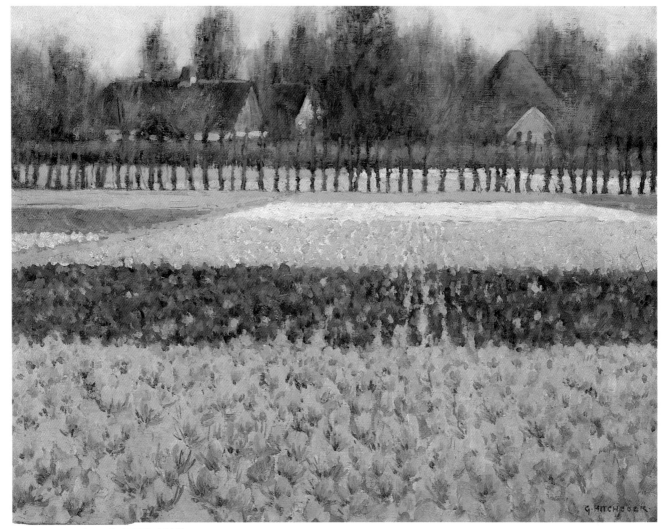

George Hitchcock (1850–1913)
Spring Near Egmond

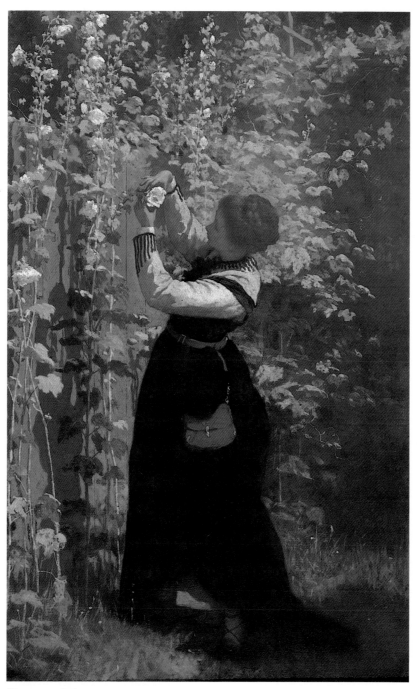

Eastman Johnson (1824–1906)
Catching the Bee, 1872

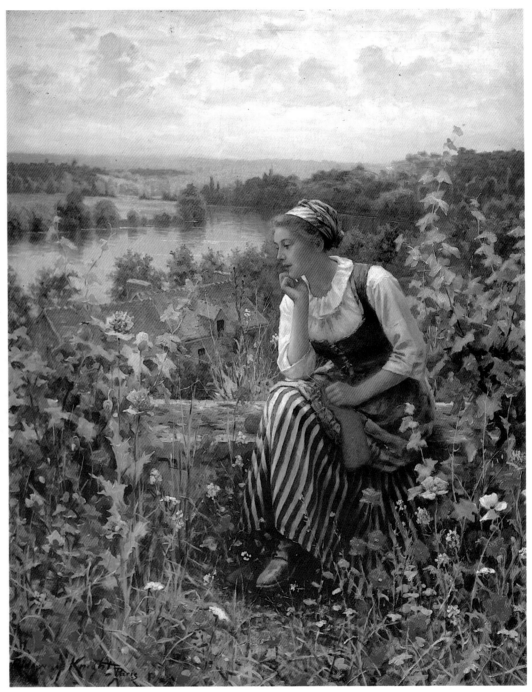

Daniel Ridgway Knight (1839–1924)
Normandy Girl Sitting in Garden

the period of the "natural garden." This was admired by many, but also criticized by a few, most notably by Candace Wheeler, a leader of the arts and crafts movement in America at the end of the century. In her lovely volume, *Content in a Garden,* published in 1901, with delicate illustrations by Mrs. Wheeler's daughter, the artist Dora Wheeler Keith, Candace Wheeler contrasted Thaxter's garden and home:

> A great part of the beauty of Mrs. Thaxter's house in the Isles of Shoals was made up of flowers. It was far more enjoyable than her garden, where the flowers grew luxuriantly at their own sweet wills, or at the will of the planter, never troubling their heads about agreeing with their neighbors. I remember it as a disappointment that a woman with so exquisite a sense of combination and gradation in the arrangement of flowers, should have so little thought of color effect in her garden.

> But in the house! I have never anywhere seen such realized possibilities of color! The fine harmonic sense of the woman and artist and poet thrilled through these long chords of color, and filled the room with an atmosphere which made it seem like living in a rainbow.[34]

That floral environment of another sort was, in fact, painted by Hassam in 1894: *The Room of Flowers.* This was a tribute to Celia Thaxter, wherein a purposeful confusion of furniture, objects and many, many floral bouquets reflect the persona of the woman, though the reclining female figure, almost lost in the clutter, is too young to represent Celia herself.

However, Hassam had portrayed Celia two years earlier, not in her Appledore home, but outside in the garden; the silver-haired Celia in a vivid white dress is one of Hassam's best-rendered figures. She towers up over the climbing blooms, yet stands humbly looking down upon her creations, and silhouetted against sea and sky. It is portrait, landscape, still life altogether.

One visitor to her summer salon recalled Celia Thaxter very much in Hassam's pictorial terms; she was ". . . occupied in her regular morning occupation of gathering flowers from the famous little garden. Dressed in white, with a thin white fichu crossing over her bosom, her face and figure express the abundance of health which the pure air is warranted to bestow. Her tender watchfulness over the flowers, and her really affectionate manner of gathering them do not need the explanation of her words, 'Oh, I love the flowers! Other people exclaim over them and say, "Aren't they lovely?" but I feel about them differently, and the flowers know that I love them.' "[35]

Most visitors to Appledore in Celia Thaxter's time were enamoured of the garden, unlike Candace Wheeler. Maud Appleton McDowell, for instance, wrote: "Her garden, too, was unlike any other garden, although more beautiful, perhaps, than the more conventional gardens I have seen lately; for it was planted all helter-skelter, just bursts of color here and there,—and what color! I have been told that the sea-air makes the color of flowers more vivid than they appear in inland gardens. Certainly, it was so in this garden. When I spoke of the tangled mass of flowers she said, 'Yes, I plant my garden to pick, not for show. They are just to supply my vases in this room.' "[36]

That garden also was the basis for the beautiful series of watercolors painted by Hassam to illustrate Celia Thaxter's last book, appropriately

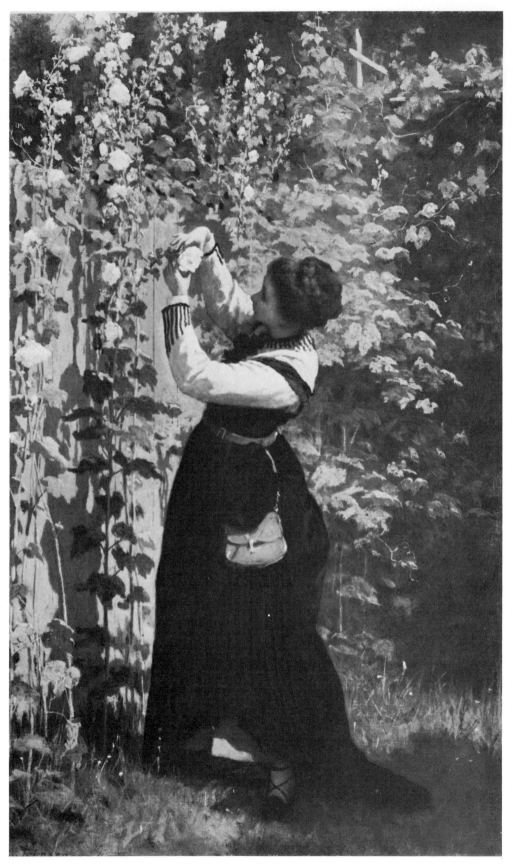

Eastman Johnson (1824–1906)
Catching the Bee, 1872

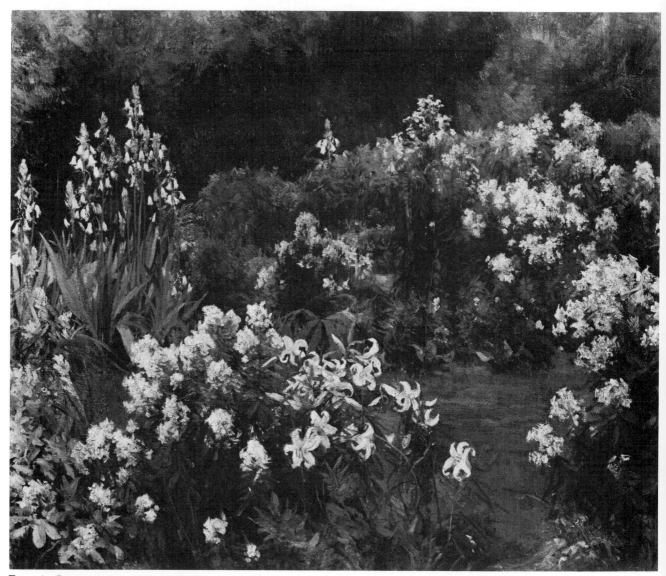

Francis Coates Jones (1857–1932)
Flower Garden, 1922

named *An Island Garden*, published in 1894, the year the author passed away. Twenty-two Hassam watercolors are reproduced as illustrations and head-pieces, some of which, such as the *Home of the Humming-Bird*, are located. Other gorgeously colored garden watercolors by Hassam of the same period may have been done for consideration in the volume and not used. In all of them, Hassam's brilliant ability in the manipulation of the rich wet washes at the same time gives a convincing formal suggestion and yet renders the flowers and their landscapes with great vitality.

Poppies figure particularly among Hassam's watercolors for *An Island Garden*, as poppies are outstanding in Thaxter's narrative. She wrote: "I am always planting Shirley Poppies somewhere! One never can have enough of them, and by putting them into the ground at intervals of a week, later and later, one can secure a succession of blooms and keep them for a much longer time,—keep, indeed their heavenly beauty to enjoy the livelong sum-

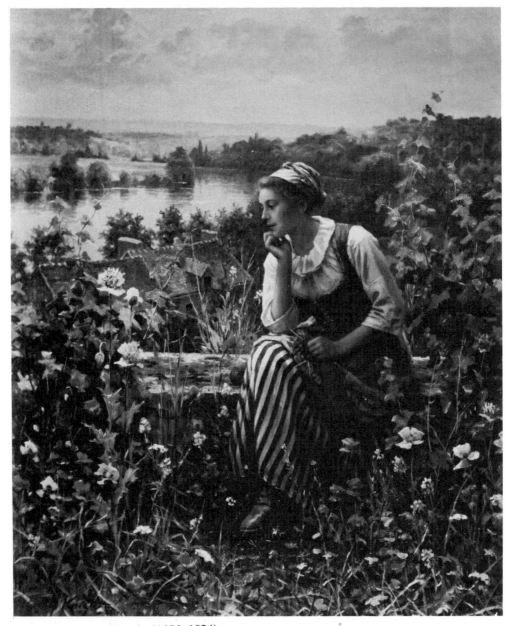

Daniel Ridgway Knight (1839–1924)
Normandy Girl Sitting in Garden

mer. . . ."[37] And again: "Poppies seem, on the whole, the most satisfactory
flowers among the annuals. There is absolutely no limit to their variety of
color . . . To tell all the combinations of their wonderful hues, or even half,
would be quite impossible, from the simple transparent scarlet bell of the wild
Poppy to the marvelous pure white, the wonder of which no tongue can
tell."[38] She quotes Robert Browning:

> "The Poppy's red effrontery,
> Till autumn spoils its fleering quite with rain,
> And portionless, a dry, brown, rattling crane
> Protrudes."[39]

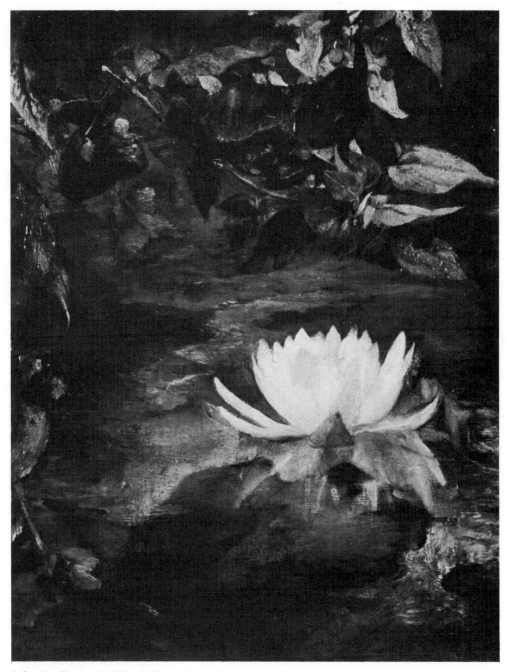

John La Farge (1835–1910)
Water Lily

And Ruskin:

> I have in my hand a small red Poppy which I gathered on Whit Sunday in the palace of the Caesars. It is an intensely simple, intensely floral flower. All silk and flame, a scarlet cup, perfect edged all round, seen among the wild grass far away like a burning coal fallen from Heaven's altars. You cannot have a more complete, a more stainless type of flower absolute; inside and outside, all flower. No sparing of color anywhere, no outside

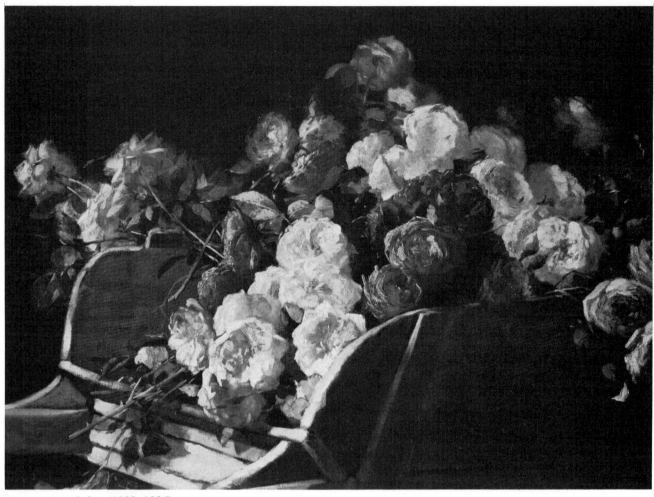

George Lambdin (1830–1896)
Roses in a Wheelbarrow

coarsenesses, no interior secrecies, open as the sunshine that creates it;
fine finished on both sides, down to the extremest point of insertion on
its narrow stalk, and robed in the purple of the Caesars. . . .[40]

After Celia Thaxter's death, the flowers on Appledore seem to have lost
much of their appeal for Hassam, though he continued to return there to paint
the rocks and the surrounding ocean. In general, both cultivated and wild
flowers, and gardens themselves, began to figure less in his art, although the
garden ambience as at least background for figural scenes, continued to ap-
pear from time to time, and floral outcropping sometimes attracted his atten-
tion such as in *Laurel in the Ledges* of 1906, painted at Old Lyme, or his *Water
Garden* of 1909.

Hassam's garden pictures in turn inspired his friend G. Ruger Donoho to
specialize in this theme beginning in the late 1890s, following a phase of
Barbizon-style landscape painting. Hassam had been an early admirer of
Donoho, and their friendship seems to have grown after Donoho settled in
East Hampton, Long Island, in 1891. Donoho introduced Hassam to East
Hampton in 1898, and it was there that Hassam painted one of his most
impressive works of that year, his *July Night*, depicting Mrs. Hassam in the

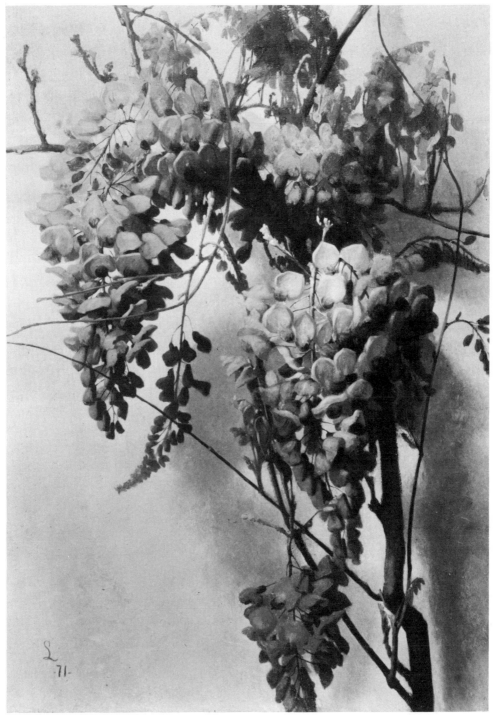

George Lambdin (1830–1896)
Wisteria on a Wall, 1871

Donoho garden, amidst Japanese lanterns. This is not a floral picture, but it was about then that Donoho himself began to specialize in this subject. Royal Cortissoz noted in his obituary for Donoho in 1916, that "He painted that garden over and over again in the same spirit in which he pottered over its flowers and hedges, loving it all and understanding it."[41] Hassam continued

to admire his friend's work, and wrote the introduction to the *Memorial Exhibition* catalogue for the Macbeth Gallery in New York. Three years later, in 1919, Hassam bought a house in East Hampton on the Donoho property on Egypt Lane.

Vonnoh's poppy pictures of the late 1880s painted abroad, and especially Hassam's Appledore paintings of flowers outdoors presaged and, perhaps, inspired, the form of floral environment painting which became a speciality of Maria Oakey Dewing. Mrs. Dewing, the wife of the Tonalist figure painter Thomas Dewing, was a pupil of John La Farge. She became a specialist in

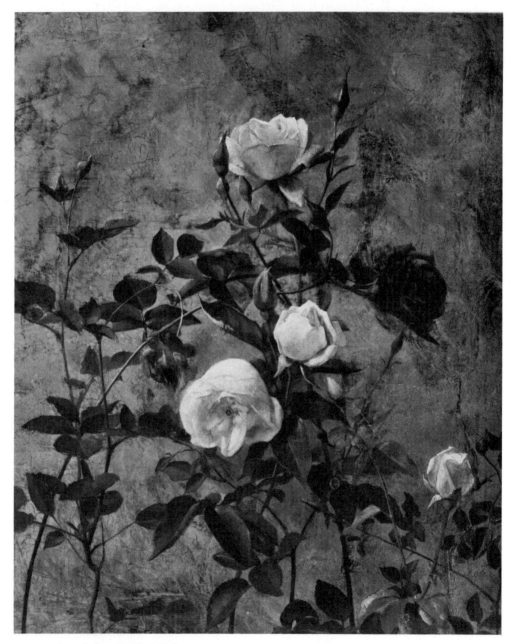

George Lambdin (1830–1896)
Roses on the Wall, 1874

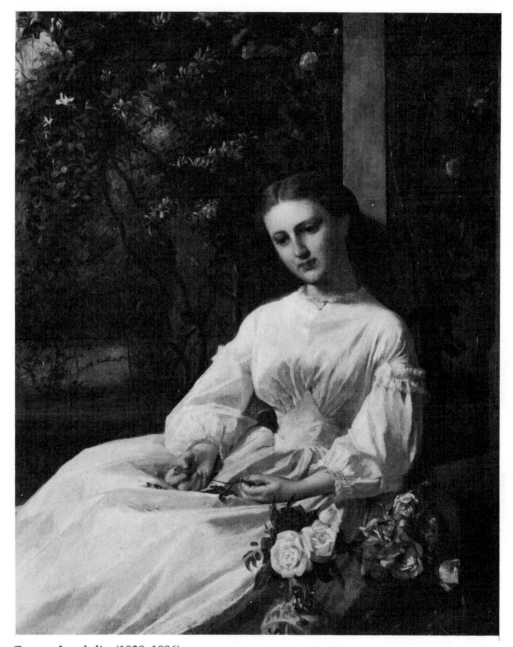

George Lambdin (1830–1896)
Rosy Reverie, 1865

flower painting. It has been suggested that Maria Dewing began painting her outdoor flower pictures in the early 1880s, earlier than her American contemporaries, and that her inspiration for such work was drawn primarily from her teacher, John La Farge, and their shared enthusiasm for Oriental art. It is true that her approach to flower painting betrays none of the Impressionist aesthetic shared by Vonnoh and Hassam, but all of her located flower pictures painted *in situ* date from the mid-1890s and later.[42]

Maria Oakey had begun her professional career as a figure and still-life painter, exhibiting several flower pieces as early as 1873 in Cincinnati, but she seems to have turned to floral specialization after her marriage to Thomas

Dewing in 1881, most likely to avoid competition with her husband, also a figure artist. Her turn to this theme was undoubtedly stimulated by the Dewings' involvement in the summer art colony in Cornish, New Hampshire, where they, among many, developed a lavish flower garden, from which Mrs. Dewing drew her subject matter. She became an expert botanist at their home, "Doveridge." Maria Dewing painted more conventional bouquets in vases, also, but the most beautiful and original of her works are those painted directly in the flower beds of their Cornish garden, such as her *Garden in May* of 1895. As she herself wrote in an important article on "Flower Painters," "If one would realize the powerful appeal that flowers make to art let them bind themselves to a long apprenticeship in a garden."[43] Maria Dewing's own apprenticeship is apparent in these works where she plunges the spectator down into the garden bed, allowing for a worm's eye view among the blooms, the leaves, the stems and vines, and in which the viewer is enmeshed in a

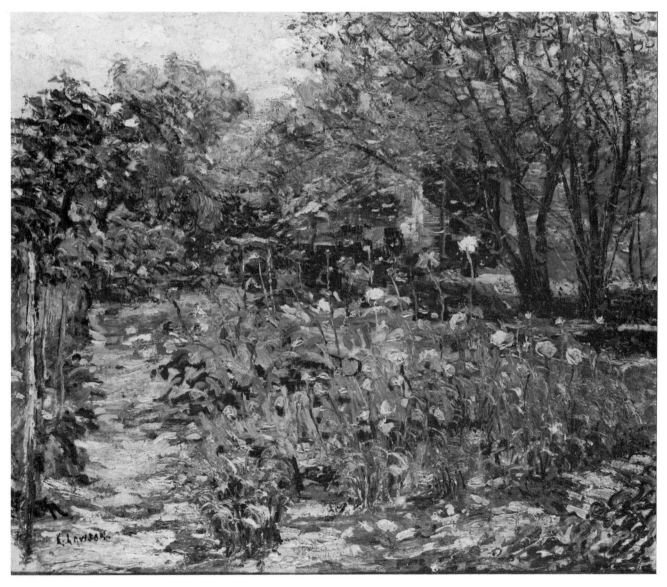

Ernest Lawson (1873–1939)
Garden Landscape

seemingly endless profusion of floral vitality, the long horizontality of the composition and format suggesting an extension of the scene beyond the edges of the picture's enframement. Sometimes, as in her unfortunate *Rose Garden* of 1901, *pro*fusion becomes *con*fusion, and the viewer is hard put to find direction or locate a vantage point amidst the botanical restlessness. Something of this seems recognized, when Dwight Tryon is reported as remarking to her: "Do you realize that if you had put that flower any further towards the edge of your canvas, you wouldn't have got it in at all, would you?"[44]

Not surprisingly, given the popularity of the bloom among flower painters of the period, Mrs. Dewing painted a poppy picture drawn from their garden cultivation in Cornish, a now unlocated *Poppies and Italian Mignonette*, owned by the great collector Charles Freer. She returned to the poppy in 1909 in her *Bed of Poppies*, drawn from a great bed of the flower developed by the Dewings

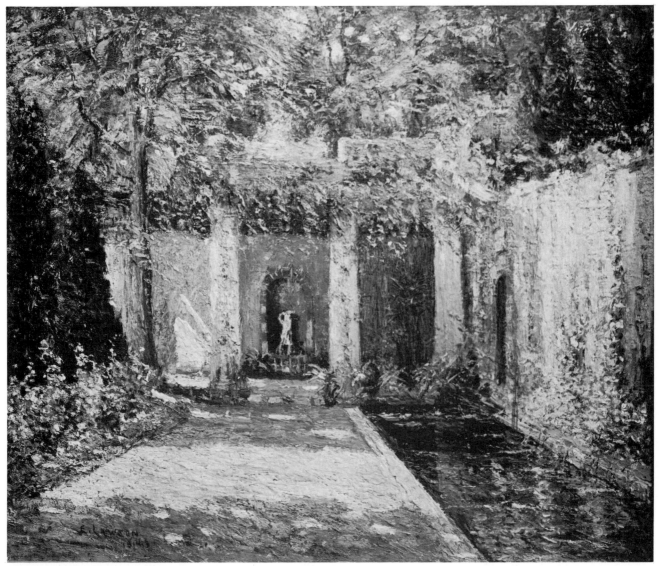

Ernest Lawson (1873–1939)
The Garden, 1914

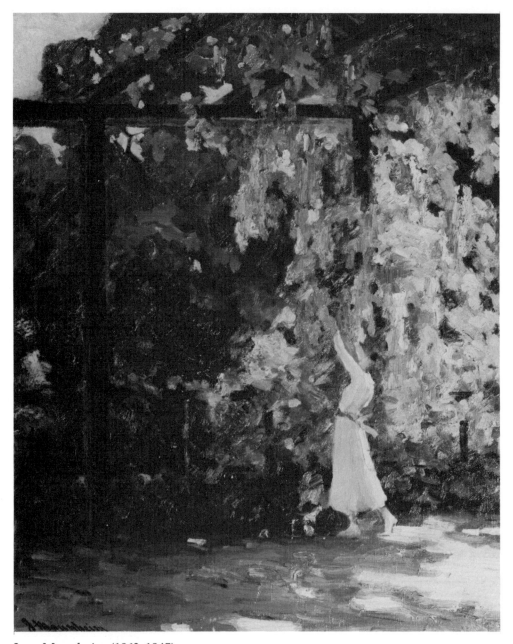

Jean Mannheim (1863–1945)
Our Wisteria, ca. 1912

at Green Hills, New Hampshire, where they began summering in 1903, finding Cornish "too social-minded" by then. Mrs. Dewing wrote of the poppy: "When I paint flowers, I paint more than I see. I paint what I know is there. For example, I know how the poppy bursts its calyx, so that when I paint poppies they are true to nature."[45]

With the poppy so featured a flower in painting of the 1880s and '90s, the question of a possibly narcotic significance or implication in its pictorialization might naturally arise. Yet, this does not appear to be the case, either implicitly in the utilization of the flower in the pictorial schema, or in the discussions of

the flower in articles particularly devoted to it, or in wider considerations of flowers, their cultivation, or their artistic representations. Perhaps given the more materialistic attitudes of the American artists and their patrons of the period, it was seldom an issue. At most, in such a relatively early treatment of the subject as the 1884 *Poppies* by the expatriate American, Frank Millet—he in whose English garden Sargent painted his several lily pictures the following

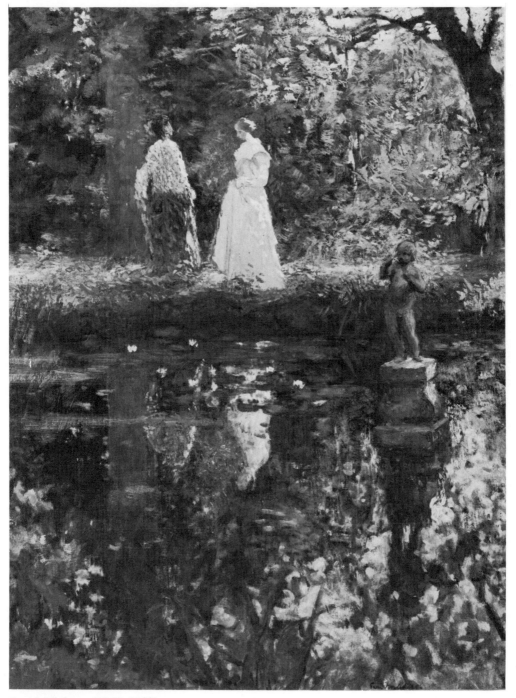

Gari Melchers (1860–1932)
Lily Pond, ca. 1925

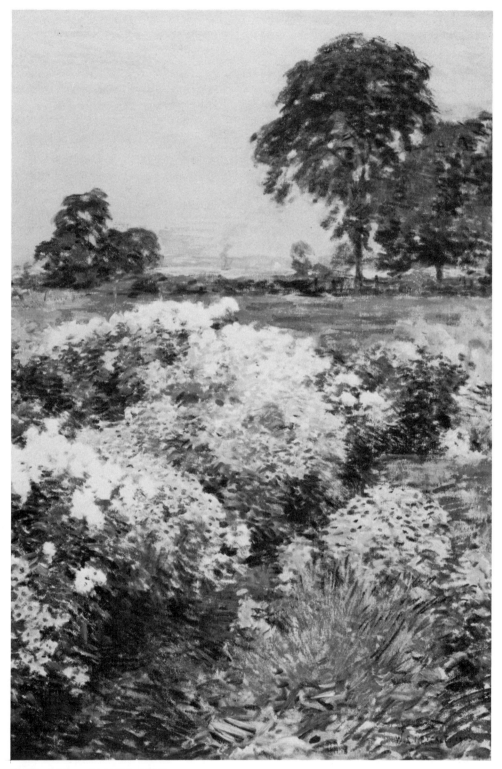

Willard Metcalf (1858–1925)
Purple, White and Gold, 1903

two years, including *Carnation, Lily, Lily, Rose*—one finds an aesthetic, late Pre-Raphaelite-tinged, and somewhat proto-Symbolist excursion into a nostalgic dream-world, in which the slow, lethargic mood is enhanced by the brilliant, seemingly, endless poppy field. An opiate sensation is, in fact, induced of time standing still, or a removal back in time to the arcadian days of the Classical era, in Millet's classical foreground figure, separated from the minute classical temple in the far background by the impenetrable poppy field. The figure's identification with those flowers—as so often, the beautiful, graceful woman and beautiful, graceful flower are likened one to the other—is underscored by her gently sinuous pose which echoes that of the flowers, including the one she is about to pick.

Floral narchosis might describe a good many of the costume pieces by American painters of this period, pictures in which an abundance of flowers, often in outdoor settings, heightens the suggestion of a retreat in time and/or place to a distant world, as well as adds a rich chromatic brilliance along with often multi-hued, exotic costuming of the figures. As in Millet's work, or in Harry Siddons Mowbray's *Roses,* and countless other paintings of the period, the fantasy is gentle and benign, with none of the morbidity or luridness which often characterizes contemporaneous European symbolism. Mowbray's picture involves a number of exotically garbed women in a sunlit outdoor setting gathering roses, while listening to the music played on a harp-like stringed instrument—the perfumed scene undoubtedly meant to invoke all the senses. The multitude of roses—literally thousands of them, would suggest this as an American counterpart to Sir Lawrence Alma-Tadema's famous *Roses of Heliogabalus,* though in conscious contrast with the vicious, suffocative event reconstructed therein.[46] Roses had a special place among Mowbray's works, with easel paintings of *The Festival of Roses* painted in 1886, *The Rose Harvest* in 1887, and *Attar of Roses* in 1894. The located *Roses* may, in fact, be the 1887 picture. Mowbray even painted a mural panel of *The Month of Roses* for the reception room of the New York Athletic Club's building on Travers Island. This was his introduction to mural painting, for which he had abandoned easel painting by 1900.

The painting of flower fields and flower gardens naturally appealed to and involved most of those American artists connected with the Impressionist movement, and therefore some, at least, of the group called The Ten American Painters, a dominantly Impressionist organization founded in the winter of 1897–98, which began holding annual exhibitions the following spring. One of their number, Willard Metcalf, painted what may be the most direct homage to Monet's pictures of fields of poppies, his *Poppy Garden* of 1905. Here, a parallelogram of the brilliant red blooms bisects the surrounding field while leading the eye to the Connecticut River shore at Old Lyme, perhaps the garden of his colleague, Clark Voorhees. Metcalf was induced to join the art colony there that year by his good friend, Childe Hassam, whose paintings of the previous decade are almost certainly the immediate prototype for Metcalf's painting. Metcalf had just begun, the previous year, to take up the aesthetic direction already practised by Hassam and, as in Hassam's earlier Appledore pictures, Metcalf affirms a sense of place here—a concern for the topography of the coast, and of the specific nature of the near foliage, though the arching compositional curves, the long brushstrokes and especially the

square format of the painting are more peculiarly Metcalf's own. Metcalf devoted his career from this time on to the glorification of New England scenery, though the flower field was not a common element in his art.

Another of the leading American Impressionists, and perhaps the most admired of the Ten American Painters until his untimely death in 1902, was John Twachtman. Twachtman's most spectacular efforts in the depiction of growing flowers *in situ* plunge the spectator directly into the garden tangle, somewhat akin to the garden paintings of Maria Dewing, the wife of his fellow member of The Ten. Twachtman, however, chose a vertical format for these works, which suggests an even greater density of foliage and flowers, while necessarily confining the spread of the floral display. Utilizing a looser and less structured brushwork than Mrs. Dewing, and not evincing her botanical concern, Twachtman's canvases have a brilliant vivaciousness, whether in the more dramatic *Tiger Lillies* or the appropriately more fragile and delicate *Meadow Flowers*. Nor was Twachtman uninterested in more cul-

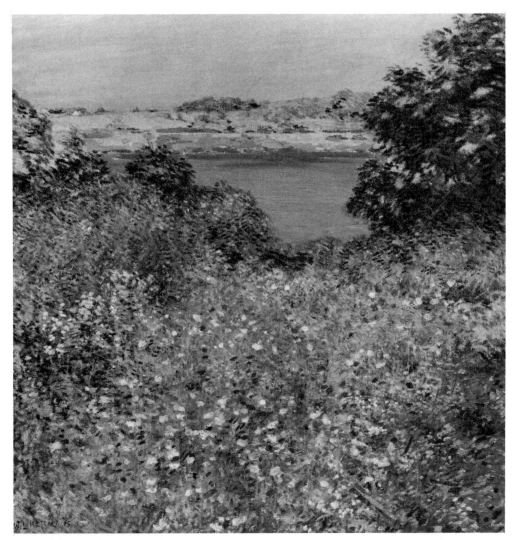

Willard Metcalf (1858–1925)
The Poppy Garden, 1905

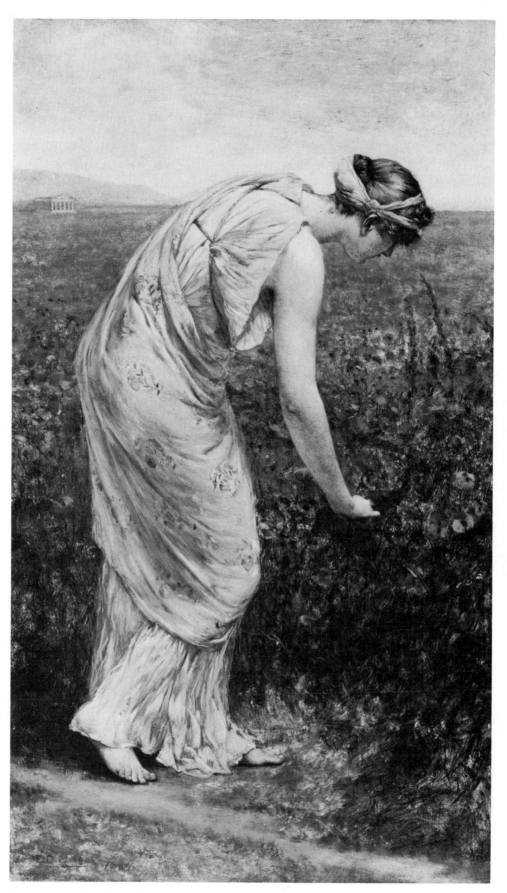

Francis David Millet (1846–1912)
The Poppy Field, 1884

tivated flowers, as he demonstrated in his *Azaleas*. Working with a less defining aesthetic, Twachtman does not individualize or differentiate his flowers here, but rather blends them into the total landscape, all illuminated with a clear and dramatic light somewhat unusual for him. Twachtman's excursions into flower painting, like most of his work, are not dated, but one of at least three pictures of tiger lilies that he painted was exhibited in 1893, and this would seem to be an acceptable approximate date for such works.

On Twachtman's death, his place among The Ten was taken by William Merritt Chase, who, from the late 1880s on, had been involved with many of the aesthetic concerns shared by the American Impressionists. Successively in Prospect Park, Brooklyn, in Central Park, and, from 1891 on, on the Long Island coast at Shinnecock, where he conducted a school of outdoor painting, Chase displayed an ever-growing interest in colorful, sun-drenched landscapes. One might expect that an emphasis upon growing flowers would be a

Claude Monet (1840–1926)
Poppy Field Near Giverny, 1885

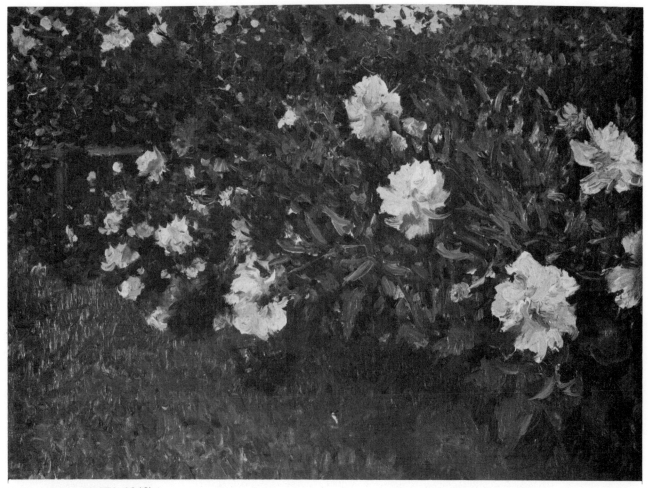

F. Luis Mora (1874–1940)
Peonies, 1916

natural concomitant. Yet, flowers figure relatively little in Chase's formal still lifes, and even less in his outdoor scenes. One might even speculate that, for all his involvement with the institution of classes for outdoor painting at Shinnecock, he remained very much an urban and urbane figure, more at home in the Tenth Street Studio building and in his subsequent New York City studios, than in a rural setting. Thus, his interest in growing flowers is, likewise, found in more urban and confined settings, such as *The Nursery* in Central Park, painted about 1890 or 1891, a house for cultivation of flowering plants to be distributed throughout the Park. Even so, flowers themselves are not conspicuous in the picture, dominated as it is by the foreground figure and the man-made architectural structures of greenhouses and nursery beds. The most noticeable floral element is actually the bouquet in the hands of the principal figure, a brilliant color accent contrasted with the brilliant white foil of her outfit. Two decades later, around 1911 when Chase was conducting his summer classes abroad in Florence, he returned to the theme of the nursery, depicting the *Orangerie* of the Chase Villa in Florence, surrounded by flowering shrubs. Again, the architectural structure provides a firm underpinning for the vibrant brushwork and rich coloration of Chase's art.

Among the artists of The Ten more oriented toward figure painting, Robert Reid was the most conspicuous for his presentations of a union of floral imagery and lovely young women. In Reid's *White Parasol,* the figure, as in Chase's less ethereal lady in the Central Park nursery, is all in white, silhouetted against an impenetrable backdrop of flowers, which also form a barrier at the picture plane; the floral background design is continued in the bouquet she has picked and carries. It is as though the young lady in virginal white had stepped into one of Reid's colleague, John Twachtman's, tiger lily, or meadow flower fields. In their own time, Reid's works were described as intensely decorative, and decoration and pattern, rather than real space or even real sunlight, seem to be the artist's primary concern in his paintings of women and flowers. Indeed, many of Reid's figure paintings were given floral titles derived from the principal blooms included, so that such pictures as his *Gladiolas, Tiger Lilies, The Canna, Daffodils, Peonies,* and *Goldenrods,* would, by their titles alone, suggest either a still life or a pure garden picture, rather than compositions dominated by the figure, which they are. That is true, also, of what is perhaps the best-known of his easel paintings, his *Fleur de Lis,* exhibited in the second exhibition of The Ten, in 1899, described by one critic as a "bewilderingly rich canvas."[47]

Surprisingly, the Boston members of The Ten, Edmund Tarbell and Frank Benson, who, like Reid, specialized to some degree in paintings of lovely women placed outdoors in brilliant sunlight, seem rarely to have concerned themselves with the garden or flower field setting. Their associate most involved with the floral environment was Philip Leslie Hale. Hale was one of the most original of the American Impressionists, and though he shared similar pictorial interests with Tarbell, Benson, De Camp, Paxton, and other of his Boston colleagues, he was more concerned than they with dissolving form in the pursuit of demonstrating the composition of light itself. Hale's oeuvre is particularly in need of further study, for it ranges from the tightly and brilliantly rendered forms of his *Crimson Rambler* and *Hollyhocks* to the more typical diffusion of *In The Garden,* where figure, flowers, and landscape are softly enveloped in yellow sunlight. The latter, more fully Impressionist works, are actually earlier pictures, for Hale was one of the earliest American converts to that aesthetic, turning to it in the summer of 1889 while he was in Giverny in France. His paintings done there, and in New England from 1893 on, when he returned to this country to teach at the school of the Museum of Fine Arts in Boston, are among the most colorful of any American of the period, and many of them are scenes of young women in the sun, painted in the garden of his aunt, Susan Hale, in Matunuck, Rhode Island. About the time of his marriage in 1902, or shortly after, Hale's work appears more conservative, more academic, probably under the influence of his own involvement in teaching; but attractive young women in flowering gardens remained a prominent theme in his art, a theme which was well received critically, for the *Crimson Rambler* was purchased out of the annual exhibition of 1909 by The Pennsylvania Academy of the Fine Arts. Many of Hale's outdoor paintings are set in gardens, though the flowers appear more prominently in those more crisply rendered. In *Crimson Rambler,* for instance, the lovely lady, all in white save for a wide, flaming red sash, echoes in reverse the form of the glorious rose bush of the same hue as the sash. Hale's wife,

Henry Siddons Mowbray (1858–1928)
Roses, ca. 1900

the noted artist Lillian Wescott Hale, was an avid gardener.

It was Abbott Graves, however, a close Boston friend of Childe Hassam, who became the leading flower and garden specialist in Boston, perhaps the leading such artist in this country; a contemporary biographical article referred to him as "A Painter of Colorful Gardens."[48] By the age of sixteen he was working in a greenhouse and painting flowers, and he appears to have determined to pursue this subject as a career. He was already known as the best flower painter in Boston by 1883, and the following year he went abroad to study with a leading European flower painter, Georges Jeannin.

Graves was an excellent still-life painter, but he was determined to broaden the spectrum of his art, and in Venice where he had gone to avoid the cholera that had broken out in Paris, he painted a large picture, *Flowers of Venice,* depicting a gondola laden with flowers and potted plants in bloom. Returning to Boston in 1885, Graves painted his large picture of *The Chrysanthemum Show,* which became one of his best-known works.

The Chrysanthemum Show offered Graves the opportunity of presenting a lush display of a favorite flower, but it was also the documentation of a

Henry Roderick Newman (1833–1918)
Anemones, 1876

prominent event in Boston, and in horticultural circles, generally. Flower shows, popular civic events in this country at the time, had featured the chrysanthemum since it first made its appearance in an American flower show in 1830. As Samuel A. Wood wrote in 1892, "To glorify the chrysanthemum has been the leading purpose of all the large autumn shows held in recent years anywhere in the United States. There are other flowers in profusion at these shows, but the queenliest is the royal one that blooms in the somber season of falling leaves, when bright tints are a delight to the eye and a solace to the soul." The first special chrysanthemum exhibition was held at Massachusetts Horticultural Hall in November 1868. Another one-day show took place in 1879, a two-day one in 1883, and a great three-day show in 1886.[49] This is the event commemorated by Graves, in a city more famous for its love of flowers than either New York or Philadelphia. Wood also wrote that the gardeners of Tokyo reared many varieties of chrysanthemum for the garden of the emperor, and that there was an imperial chrysanthemum show each year. On a smaller scale, the Japanese fascination with the chrysanthemum is recorded by the California painter, Theodore Wores, one of the earliest American artists to work in Japan; Wores was there from 1885–87, and again from 1892–94. Wores painted *A Chrysanthemum Show, Yokohama*, prob-

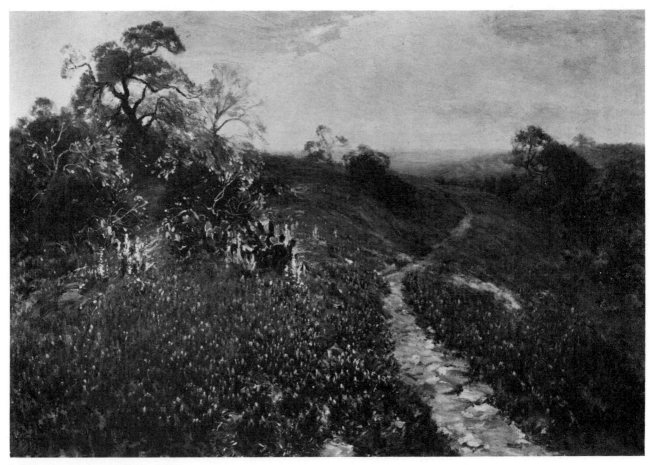

Julian Onderdonk (1882–1922)
Bluebonnet Field, 1912

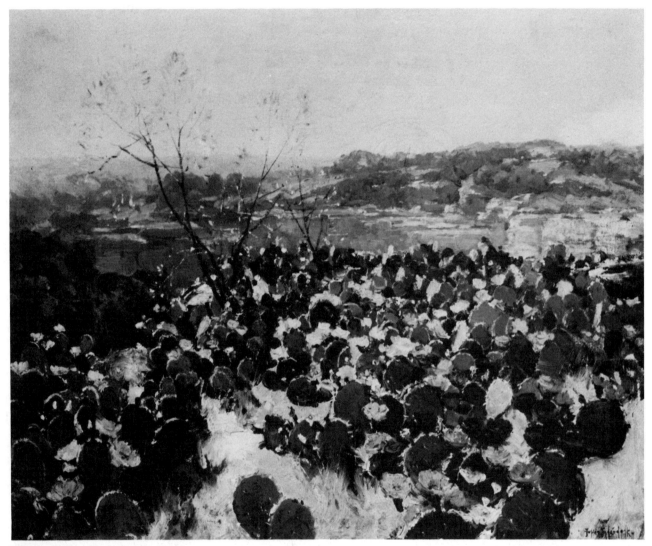

Julian Onderdonk (1882–1922)
Cactus Flower

ably during his second trip to the Far East, and also wrote articles about
Japanese flowers and flower arrangement, and one specifically about the Japa-
nese chrysanthemum.[50]

Abbott Graves' recording of the Boston chrysanthemum show was a unique
endeavor for him but while he was also fascinated with recording genre
scenes in Kennebunkport, Maine, his reputation lay with his many ren-
derings of flower gardens and equally, of flower bedecked architecture—
doorways, trellises, and the like. Graves' garden pictures often include
figures, generally of women, and sometimes these figures, as in his pure
genre interiors, may seem a bit stiff, though that stiffness often creates an
effective contrast with the lush vitality of his energetic blossoms in the garden
pictures. The flower-framed doorways of Colonial and other style houses are
usually without figures, a kind of outdoor, native equivalent to the French
rococo interiors painted by Walter Gay. His interest in this theme developed

later than the garden pictures, and shares with many garden paintings a colorful, sun-dappled aesthetic obviously informed by Impressionism.

Not surprisingly, the theme of the floral environment was taken up even more eagerly by those Americans who expatriated themselves to Giverny in France, working as they did alongside Monet in the little French village where he cultivated his exquisite garden, and painted it so constantly. One of these was Theodore Butler, who in 1892 married Suzanne Hoschede, one of

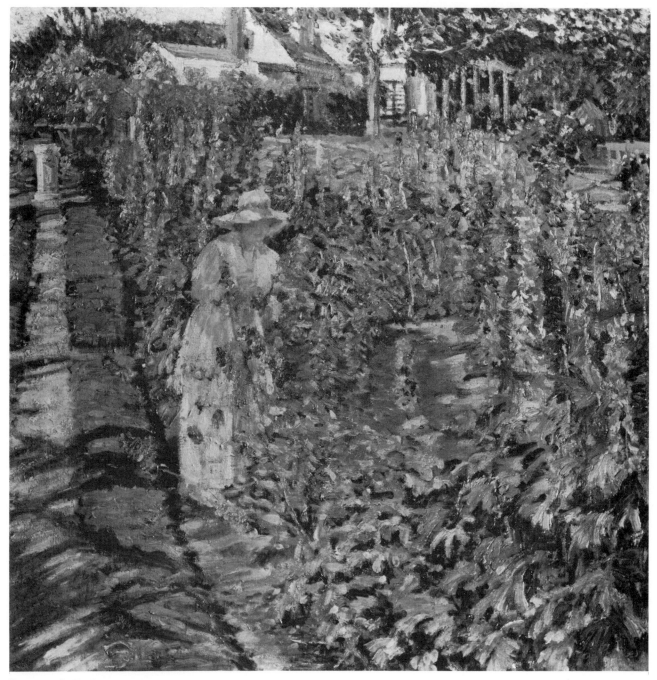

Lawton S. Parker, (1868–1954)
Woman in a Garden

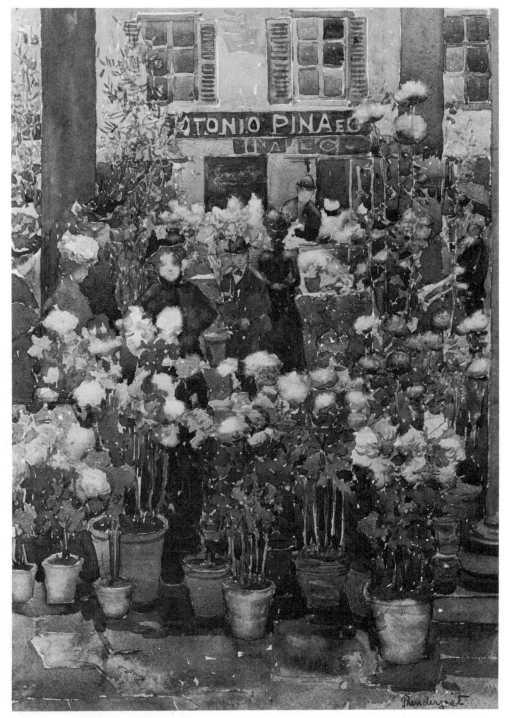

Maurice Prendergast (1859–1924)
Italian Flower Market, 1898

Monet's four step-daughters. During the 1890s, Butler painted a good many garden scenes such as *Un Jardin, Maison Baptiste*, of 1895, in emulation of those of his step-father-in-law, and some were shown in his first one-man show at the Galerie Vollard in Paris in 1897, though his pastel palette and unstructured composition differ from Monet's own work. Even before the turn of the

century, however, in pictures such as *The Entrance to the Garden Gate, Giverny*, of 1898, Butler had already begun to veer into a Post-Impressionist aesthetic, anti-naturalistic and more decorative, where patterns of sinuous, generalized forms in hotter, summery tones dominate. Butler remained the most long-lasting American presence in Giverny. In the 1890s, the sculptor Frederick MacMonnies, and his wife, the painter Mary Fairchild MacMonnies, took a house in Giverny, and there they developed an outstanding garden which Mary MacMonnies painted a number of times. Growing flowers, and women among flowers, were important themes for this still too-little known woman artist, who achieved great fame for her mural of *Primitive Woman*, installed in the Woman's Building in the Columbian Exposition in Chicago in 1893, the companion to Mary Cassatt's *Modern Woman*. Another mural specialist, the American, Will Low, who married Mary MacMonnies in 1909 after her divorce from Frederick MacMonnies, had previously painted scenes in the MacMonnies' garden in Giverny and had an exhibition of his Giverny garden pictures at Samuel Avery's New York art galleries in March of 1902. Low had been a visitor to Giverny as early as 1892, and yet another mural painter, William De Leftwich Dodge, settled into the little Normandy town in 1898, invited there

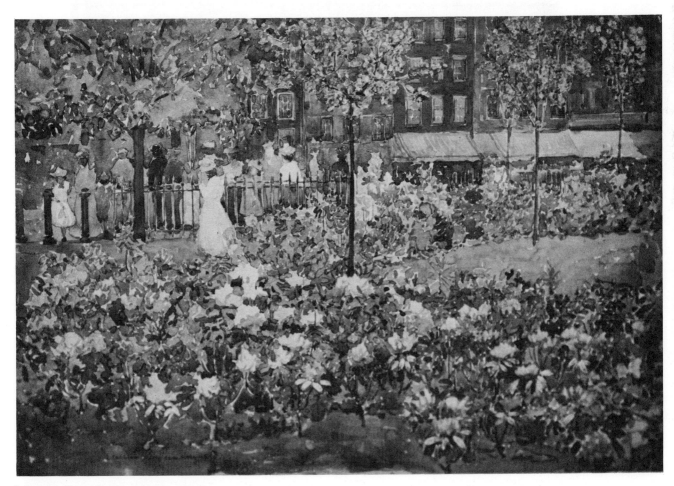

Maurice Prendergast (1859–1924)
Rhododendrons, Boston Public Gardens,
 1899

Joseph Raphael (1872–1950)
Tulip Field, Holland, 1913

by the MacMonnies. A figure specialist, Dodge painted a number of paintings of women in the walled gardens there, from the increasingly popular theme of the nude in sunlight, to his major statement of our theme in *Nun in Giverny Gardens* depicting his favorite Parisian model, Georgette, dressed in a nun's habit, and posed among the lilies in brilliant sunlight in his garden.

Another, very original artist living there was Frederick Frieseke, in the early years of the twentieth century one of the most famous of all American painters. Frieseke's specialty was the painting of women, or of gardens, or frequently both, in brilliant chromatic splendor and intense outdoor summer light.Frieseke's forms are often quite robust, his figural inspiration seeming to draw more from Renoir than Monet or any of the other Impressionist masters, while his love of decorative patterning was akin to Reid's, and equally adept. In an interview in the *New York Times* in June of 1914, at the height of the artist's fame, he explained his aesthetic: "I know nothing about the different kinds of gardens, nor do I ever make studies of flowers. My one idea is to reproduce flowers in sunlight. . . . If you are looking at a mass of flowers in the sunlight out-of-doors you see a sparkle of spots of different colors; then

Joseph Raphael (1872–1950)
The Garden, 1915

paint them in that way." Frieseke's most vivid garden pictures date from 1906 to 1919, when he lived next door to Monet. Later, after moving to Mesnil-sur-Blangy in Normandy, he concentrated somewhat more on domestic in-teriors.[51]

Frieseke, in turn, exerted an influence upon other Americans who worked in Giverny, often emulating his manner. One of these was the Ohio painter, Karl Anderson, brother of the writer Sherwood Anderson. Anderson met Frieseke again in Florence in 1910, having been a fellow student of his at the Art Institute of Chicago in 1893, and accepted his invitation to summer in Giverny. Anderson's *Wisteria*, of 1915, derives its theme of the woman in a

sunlit garden from Frieseke, but its simplified form, flat patterning, and en-
crusted impastos suggest a younger, more modern sensibility than Frieseke's.
Edmund Greacen settled in Giverny for several years beginning in 1907, be-
coming friendly with Butler, Frieseke, and other artists there, though meeting
Monet, himself, only once. Many of Greacen's Giverny pictures are garden
scenes, a preference he transplanted to the art colony in Old Lyme, Connecti-
cut, where he summered between 1910 and 1917. Frieseke's paintings of
women in garden settings seem particularly akin to those painted by the
Chicago artist, Lawton Parker, who is known to have worked in Giverny from
1902 to 1913, and also to those of the Chicago painter, Louis Ritman, who was
in Giverny about the same time as Parker. Both artists specialized, as did
Frieseke, in two not-unrelated themes, the nude outdoors in sunlight and the
woman in the outdoor flower garden, and all three painters worked in a
similar Impressionist mode and were critically linked in the American art
periodical press.

The various manifestations of the floral environment in painting at the turn-
of-the-century, beyond garden and flower field painting, included the repre-
sentation of flower markets as well as flower shows. For the most part,
however, our artists tended to prefer foreign, exotic settings for these scenes.
This was undoubtedly in part due to the appeal for patronage that such works
would offer—recollections of cosmopolitan travel, familiarly exotic locales, yet
humanized in the traffic of universal symbols of innocent loveliness. In part,
too, such foreign preferences may simply reflect the realities of the choice.
That is, artists, such as Childe Hassam, who frequently depicted Parisian
flower sellers on his several trips to France; the little-known Chase student,
Luther Emerson van Gorder, who worked in Toledo, Ohio, specializing in
Parisian street scenes; Eleanor Greatorex; or the young Maurice Prendergast,
may have chosen to paint French and Italian flower markets because they
were intrinsically lovely sights and they were there to record them. In con-
trast, Elizabeth Bisland noted that "the market for the cut flowers of New York
is a small and dingy saloon where salesmen and purchasers can refresh them-
selves with mixed drinks between the opening of fresh boxes. Not much of
the poetry of the trade is apparent."[52]

Prendergast's *Italian Flower Market* was one of the works acquired by Mrs.
Montgomery Sears, the artist's first major patron, whose support enabled him
to travel to Venice in 1898–99, when he produced some of his finest, most
vivid watercolors of the city and its life. This flower market picture is more
spatially concentrated and more dense than most of his Venice scenes, how-
ever, and the figures, mostly women, among the tall potted blooms are almost
indistinguishable from the flowers themselves. As with Chase, one would
expect to find a wealth of flower pictures by Prendergast, given his attraction
to parks and public gardens, but his views of these are often devoid of flow-
ers, and even flower still lifes are not frequent in his oeuvre. Perhaps the most
significant exception is his *Rhododendrons, Boston Public Gardens* of 1899, the
year he returned from Venice, where the flowers are less compact, lighter and
more animated in their exuberant watercolored washes than in the Italian
work of the year before. But in general, the figures themselves became the
equivalent of colorful, exuberant flowers in his pictures.

Prendergast was one of "The Eight," associated with the so-called Ashcan

School of the early years of the twentieth century, though his joyous art, informed by European-inspired Impressionism and Post-Impressionism was perhaps the least integrated with Ashcan aesthetics. In general, that group of artists had serious concerns inimical to the joyous harmonies of man and nature, wherein the flower often became a surrogate for maidenly beauty or youthful innocence. Yet, the floral environment does appear at least occasionally in the work of other of "The Eight," including several vivid garden pictures by the landscape specialist of the group, Ernest Lawson, who adopted a particularly flame-like palette for the vivid blossoms of his several garden pictures. John Sloan's art was more figure-oriented, and, in his most vital years, centered about the urban world, often at nighttime. Not surprisingly, therefore, the most vivid of his rare excursions into floral painting is his 1907 *Easter Eve* in which animated figures are involved in a transaction over a purchase from a rich display of lilies illuminated by artificial light. The blossoms themselves are just barely defined in lusty impastos, bright accents against the darkness of the costumes, the umbrellas and the rainy night itself. Gifford Beal, whose aesthetic is related to the cheerier aspects of Ashcan School painting and to the allied work of George Bellows, created probably the best known and most monumental garden picture of the period, *The Garden Party*.

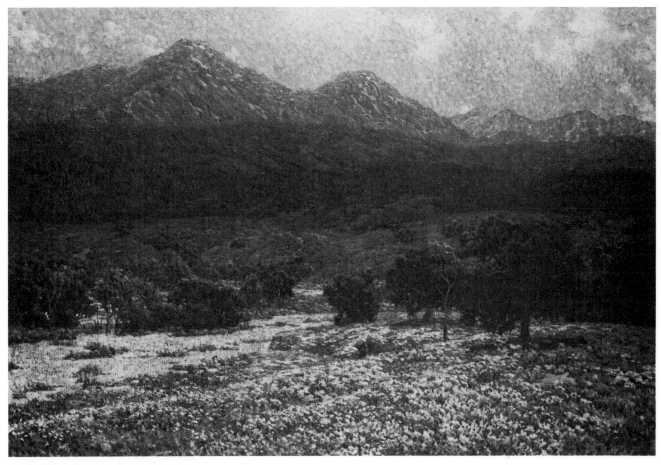

Granville Redmond (1871–1935)
California Poppy Field

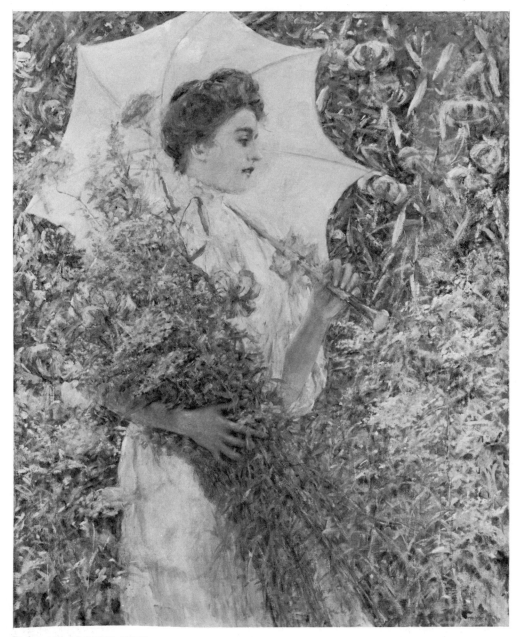

Robert Reid (1862–1929)
The White Parasol

Although given the period of the emergence of American involvement in paintings of the floral environment, and the heritage from French Impressionism of this theme, by no means all of the artists who became involved in the subject were Impressionists. A number of the more academically-oriented American artists, for instance, either occasionally or even often painted gardens and fields of flowers, though usually centering such compositions upon the human figure. One such artist was Daniel Ridgeway Knight, whose academic training under, first, Charles Gleyre, and later, Ernest Meissonier is reflected in his carefully constructed peasant imagery, although that subject was not the interest of either of his mentors. Eschewing the dour hardships of peasant life imaged by Millet, Knight allied his art with the second generation

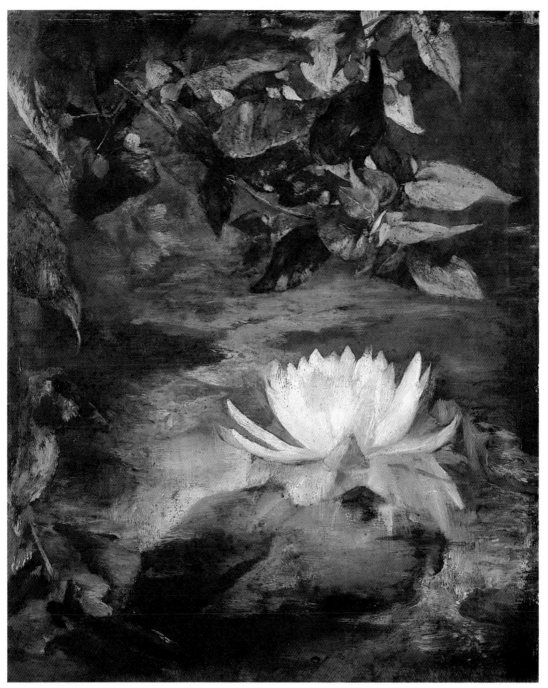

John La Farge (1835–1910)
Water Lily

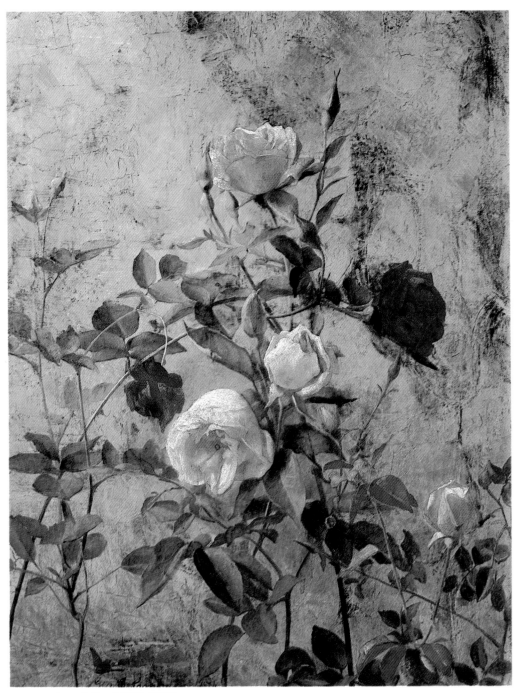

George Lambdin (1830–1896)
Roses on the Wall, 1874

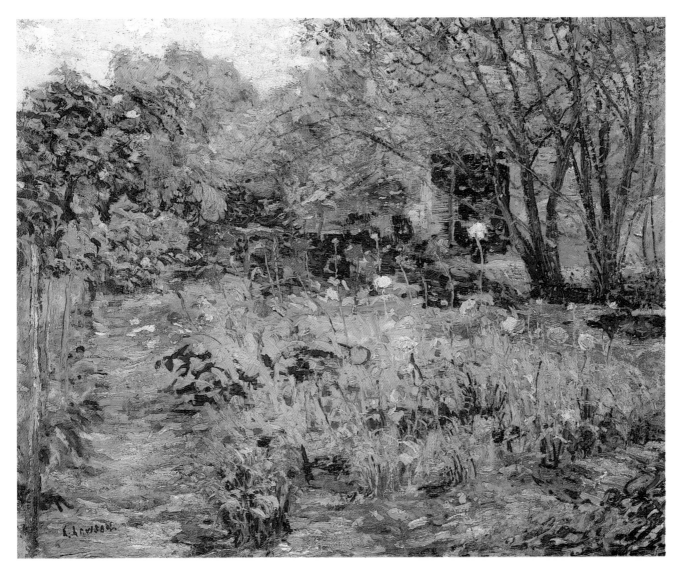

Ernest Lawson (1873–1939)
Garden Landscape

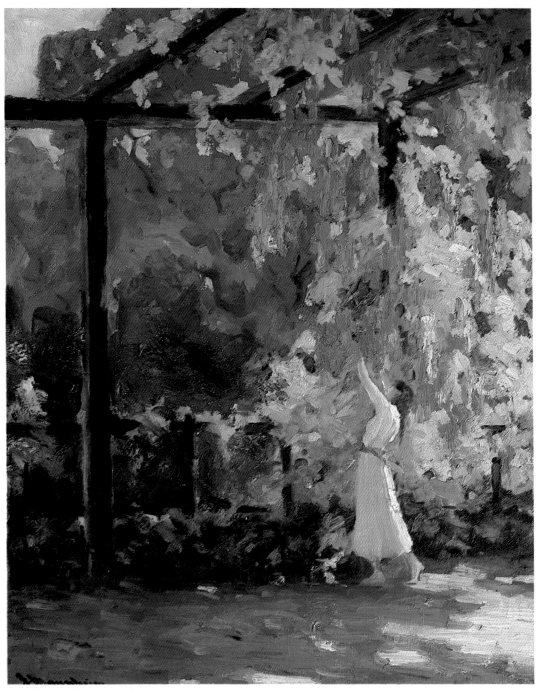

Jean Mannheim (1863–1945)
Our Wisteria, ca. 1912

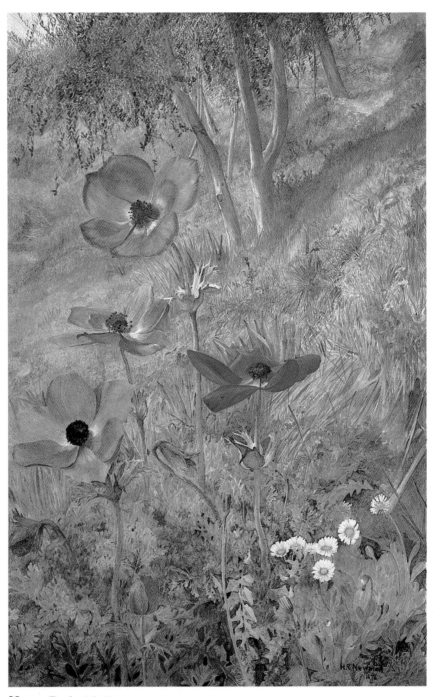

Henry Roderick Newman (1833–1918)
Anemones, 1876

Maurice Prendergast (1859–1924)
Italian Flower Market, 1898

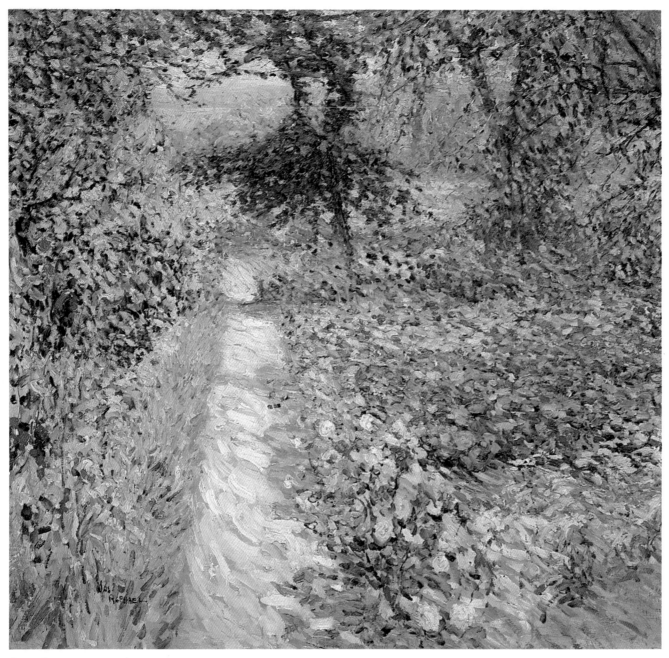

Joseph Raphael (1872–1950)
The Garden, 1915

Barbizon figure tradition, not dissimilar to that of Jules Breton. His work centers upon the lovely young peasant woman, usually shown out-of-doors either at rest or in contemplation, or occasionally at light work—never strong toil. Often these young women—sometimes alone, sometimes in groups, sometimes at courtship—are immersed in rather lavish, if rural, French peasant gardens, the flowers mirroring the loveliness of the young peasants, and belying the hardships of their life, which were pictorially pursued by so many of Knight's contemporaries.

Louis Comfort Tiffany sought French academic training a few years after the end of the Civil War, even earlier than Knight. Though he became particularly noted for his North African and Near Eastern paintings, before beginning to concentrate in the decorative arts, for which he is best remembered, the paintings he did back in America constitute a translation of the French peasant aesthetic to rural America. Some of the more relaxed and idyllic of these, such as *At Irvington-on-Hudson* set his figures (here probably being the artist's wife and son) in fields of simple meadow flowers. Albert Herter was a younger artist, whose father, Christian Herter, was also a major figure in decorative artistry at the end of the century. So, in fact, was his son who developed the Herter Looms for hand-loomed tapestries, but he was also a noted mural and easel painter. *The Herter Family in Paris* exhibits an elegant formality, the antithesis of Tiffany's family group, and they are posed in a proper, cultivated garden, rather than a random flower field.

One of the most thoroughly trained of our late nineteenth century figure painters was Thomas Hovenden, who devoted his talents to historical subjects, to French peasantry, and to American rural life, including Black subjects. On his return in 1880 from his academic training abroad, Hovenden was praised for not shirking the difficulty of finishing his work "in an attempt to palm off an 'impression' as art," believing that "while 'impressions' may have an educational value for art students, they are not pictures any more than poetic thoughts are poetry."[53] Yet, a decade or so later, in the early 1890s, Hovenden was capable of producing *Springtime,* a very Monet-like garden-picture—this at the height of the vogue for this theme and of Impressionism in America; in his figure painting of the same time, such as his best-known picture, *Breaking Home Ties,* of 1890, the academic tenets of studio lighting, tightly structured form, and tonal rather than color values, dominate.

Whether at home or abroad, the floral environment became a major source of inspiration for the American artist in the late nineteenth century. Indeed, painters, in whatever land they might find themselves, often sought out the various facets of the floral ambience of the land—the more exotic, the more interesting. As has been mentioned, Hassam, van Gorder, and Prendergast, among many others, painted French flower markets; Robert Blum depicted one in Tokyo, in 1892. Blum's brilliantly conceived work gives equal attention to the figures and the flowers. For his Western audience, the former offer a world of the completely unfamiliar, the Japanese ethnicity, costumes, poses, and habitations. Balancing these, however, was the universal familiarity with, and appeal of, flowers. That appeal, therefore, endowed the inhabitants of the exotic and the remote with traits of all humanity, and created a brotherhood with the completely alien.

Another American expatriate, George Hitchcock, settled in Holland in the late nineteenth century, rather than France, and appropriately and perhaps

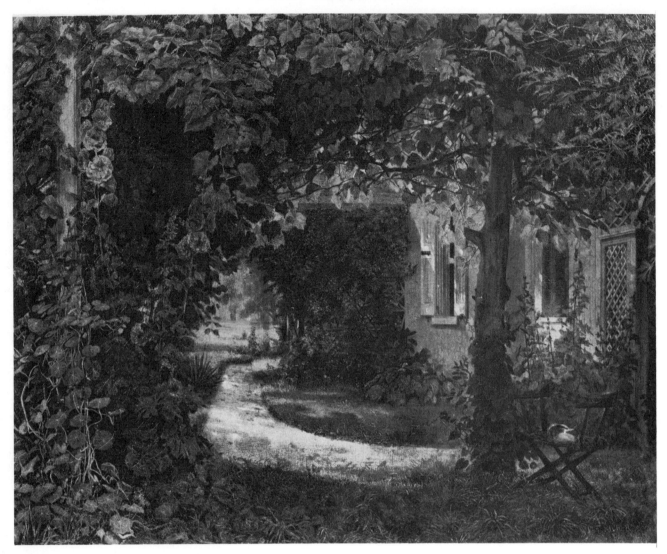

William Trost Richards (1833–1905)
*A Summer Afternoon in a Garden in
 Philadelphia,* 1859

unsurprisingly, chose to specialize in the colorful fields of tulips and occasion-
ally other flowers of his adopted land. Hitchcock first became acquainted with
the tulip fields of Holland in 1886, and a year later won instant renown for his
painting of *Tulip Culture* shown at the Paris Salon. From then on, critics
singled him out for his unusual, vividly colored paintings of long, long
straight rows of flowers, each row of a different hue, and all in brilliant
sunlight. In fact, numerous writers identified Hitchcock, or entitled articles
concerning his art, as "The Painter of Sunlight."[54]

Though Dutch painting of the period was well known and highly respected
in America, and by American artists, the native artists there worked predomi-
nantly in a variation of Barbizon aesthetic; gray and silvery tones pre-
dominated in their work. Hitchcock, the foreigner who settled in Egmond,
explored the native flower culture as Dutch artists had not. As one writer
described it, "His pictures were not pictures of pictures. They embraced a new
theme; gave to the world a picture of Holland unknown to it. A picture of a

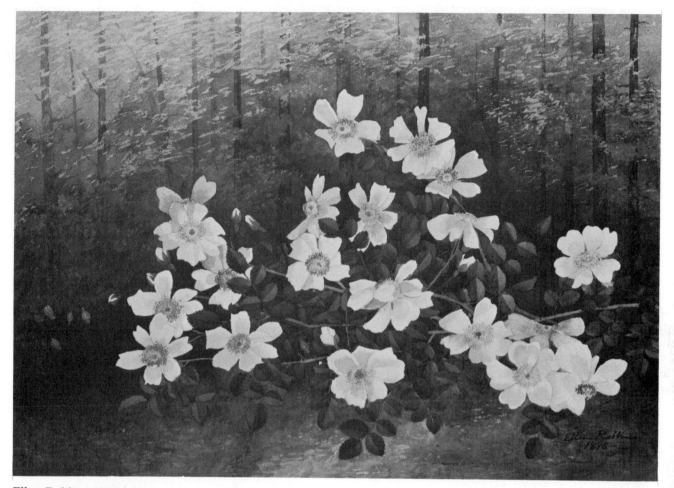

Ellen Robbins (1828–1905)
On the Forest Edge, 1896

superfluity of flower gardens, of a culture or a commerce that catered to the fancy of the continent and not to its necessity. A picture, however, to be precise, that was nothing more nor less than a reflection of himself. For that he chose these flower gardens, with their regular lines and uniform colors, in preference to those flowers that grow as nature permits . . . Throughout his life the flowers remained for him a guiding light."[55]

One must not discount the possible influence on Hitchcock, too, of Monet, although Hitchcock's academic training always remained evident in the construction of the figures that usually appeared in his paintings, customarily attractive young peasant women. Nevertheless, his turn to a high-key palette of unmixed tones occurred at just the time that Monet's impress was being felt by Americans both at home and abroad, and Hitchcock's strong compositional geometry relates, too, to the previous analysis of Monet's paintings, described in 1886. Furthermore, that same year, Monet himself had painted a series of Dutch tulip fields which offered immediate precedent for Hitchcock.

Hitchcock, however, was also very much a painter of the figure, and his Dutch peasant folk, in contrast to Knight's concentration on French peasant maids, are often endowed with religious, or semi-religious overtones, an approach to the contemporary peasant theme derived from the work of Fritz

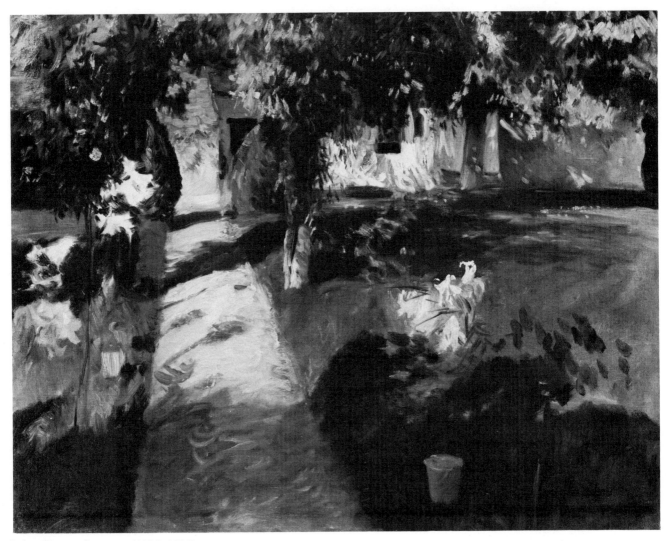

John Singer Sargent (1856–1925)
F. D. Millet House and Garden, 1886

von Uhde in Germany and most noted in Jules Bastien-Lepage's great *Joan of Arc* of 1880. Hitchcock's figures in bright sunlight, however, avoid the dour gravity and muted palette of those masters, and flowers almost always enhance the decorative gaiety of his figure pieces. *In Brabant*, of 1895, for instance, is a ceremonial if not a religious image, wherein a young woman—a bride?—holds a tulip bouquet and is placed in and against a field of sunlit flowers. Hitchcock built for himself a houseboat in Holland called, appropriately, the *Tulip*.

Hitchcock, in turn, as one writer noted in 1912, inspired followers: "Painters, awakened by a new idea, soon flocked to Egmond. Tulips and hyacinths became fashionable. . . . The Egmond school is the result of Hitchcock's paintings."[56] Charles Meltzer, the writer of this article, did not offer specific references, but about this time a somewhat younger expatriate, Joseph Raphael, began specializing in paintings of flower fields in Holland. A later artist, Raphael is generally considered one of the most significant of the California Impressionists, but, although he was an original and first-rate artist, this is somewhat misleading on several counts. Raphael derived from California, maintained his West Coast connections in exhibitions, and was accorded

John Singer Sargent (1856–1925)
Roses, 1901

appreciative recognition in local criticism in San Francisco. Much of his work was done abroad; and, painting in the early twentieth century, his "Impressionism" was at times overlaid with elements of pointillism, and sometimes too, with both structural and expressive elements derived from later, modernist aesthetic movements.

Nevertheless, by this time, the early decades of the present century, the floral environment could be found as a serious thematic interest in the work of

artists in almost all the art colonies and regional schools throughout the nation. If Raphael painted many of his flower gardens in Holland, Granville Redmond was a California artist working in the Los Angeles area, whose finest works are his pictures of the extensive poppy fields of Southern California, more often the golden poppies rather than the rich scarlet flowers featured in Monet's and Hassam's work. These flowers were noted as distinctive of the native landscape. A short article by C. F. Holder in the first volume of the important magazine, *Land of Sunshine,* in June of 1894, was devoted to the "Copa de Oro" as they were called; and in 1914, in writing about *California Romantic and Beautiful,* James George Wharton described them: "Between mountains and sea are miles and miles, on either hand, of orange orchards, lemon groves, avenues of palms, great mesas dotted over with poppies, lupines and mustard. . . ."[57]

Other California painters treated the floral environment on a more intimate, more personal level, such as the Los Angeles artist, Jean Mannheim, who painted *Our Wisteria,* or the outstanding San Francisco painter, Edwin Deakin. Deakin's *Homage to Flora* of 1903–04 displays a profusion of roses as overwhelming as those of Heliogabalus, though far less deadly, Deakin using his own garden in Berkeley as a model every morning over a period of two years. Strangely, the leading flower painter of California, Los Angeles' Paul de Longpré, often referred to as "Le Roi des Fleurs," seems to have concentrated on indoor arrangements of flowers in watercolor, although his Hollywood home where he settled in 1898 was surrounded by three acres of flower gardens.

In Texas, the landscape and flower painter, Julian Onderdonk, in the period around 1912, devoted his finest talent to commemorating the native flowers of his state, the cactus flower and the bluebonnet. These, like Redmond's poppy fields, are vast landscape carpets of flowers, rolling limitlessly over a wide terrain. For both artists, the flowers themselves are distinctive to their region, while the expanse of these fields not only define the nature of the regional landscape but are symbolic of their richness and the infinite expanse of the land.

Among Chicago artists, we have noted already the activity of Lawton Parker and Louis Ritman. Gari Melchers painted some lovely garden pictures on his estate, "Belmont," in Fredericksburg, Virginia, after he settled there following his return to America in 1914. Philadelphia appears to have had less exposure to Impressionism than other major American urban centers, but by the early years of the twentieth century, her most progressive artist, Hugh Breckenridge, was producing vivid garden pictures, in a rich chromatic scale and a vivacity of brushwork almost Fauve in its dynamic expressivity. The artist's thematic preferences did not go unnoticed; when a group of Breckenridge's works were exhibited in Buffalo in 1908, one writer stated: "Mr. Breckenridge evidently is very fond of flowers; there is a considerable number of garden pictures in the collection, and all are fine in composition and color and are extremely decorative in character."[58] Breckenridge at this time was also "spreading the gospel" at the Darby Art School which he founded in 1900, and moved two years later to Fort Washington, Pennsylvania, where he had named his home "Phloxdale."

If Western artists appeared to emphasize the wide terrain dotted with na-

Walter Shirlaw (1838–1909)
Poppies

tive field flowers, the flower pictures produced in the art colonies of the North East tended to be more cultivated and domestic. In Cragsmoor, up the Hudson, Helen Turner and Charles Courtney Curran explored the subject—she in a more painterly manner, Curran often in a tighter and harder technique, but both concerned with warm, enveloping sunlight and bright Impressionist color. Curran's enthusiasm for floral imagery and the floral setting, however, was long-lived, and it can be identified far back in his early work, such as the marvellous *Lotus Lilies* of 1888, where the gigantic blooms seem to overwhelm the demure beauties in the boat who sedately pick them. The titular

identification refers also, of course, to the lovely ladies, themselves, who are isolated in their boat upon the lily pond, a watery *hortus conclusus* of innocence and purity. As Curran himself was to write, "One of the pleasantest ways to paint flowers out-of-doors is in combination with figures. . . ."

Finally, in what was perhaps America's most famous regional school, that which developed in Old Lyme, Connecticut, beginning in the last years of the nineteenth century, the picture of the cultivated garden was a much explored theme. For a few years, Old Lyme had been the haven for painters producing Barbizon-derived poetic landscapes in soft golden brown tones, stylistically

John Sloan (1871–1951)
Easter Eve, 1907

referred to as "Tonalist." But with Hassam's appearance at the art colony in 1903, the Tonalist aesthetic retreated before the onslaught of Impressionism, and paintings in a high-keyed colorism, often imitative of Hassam's own style, became the norm, works such as William Chadwick's *Summer Garden*, or George Burr's *Old Lyme Garden*. Charles Voorhees was another of the leaders of the colony, and he developed a noted garden in which, as has been indicated, Willard Metcalf may have painted his masterly *Poppy Garden*, for Metcalf, too, was a frequent visitor to Old Lyme. Of the uncultivated flowers, laurel was particularly distinctive to the region, and artists such as Hassam recorded the profusion of this lovely plant, while Edward Rook presented suffusive banks of the flowers to fill and ornament the scene, making something of a specialization of laurel.[59]

The prevalence of the floral environment was not, of course, confined to American painting—far from it. In fact, the many manifestations of the floral environment in European painting were by no means solely within the Impressionist orbit. The exploration of the subject in all of Western art is obviously far beyond the scope of the present essay and exhibition, but it might be remembered, for instance, that German and Austrian artists were as fully interested in expressing the theme as were French and American ones. This includes artists within the Munich Naturalist movement, such as Johann Sperl, who rather specialized in informal garden settings, often without figures; more colorful and exuberant gardens in the work of the Impressionist-Expressionist artist, Max Slevogt; the Symbolist pictures of the Jugendstil artists, Carl Strathman and Richard Riemerschmid; and especially the non-figural work of the greatest of the Austrian artists of the period, Gustave Klimt. There were garden specialists in Europe working closer to the vein of their American contemporaries, too. While their art is today almost totally forgotten, the Spaniard Santiago Rusiñol, and the Englishman, George Samuel Elgood, were well-known in their own day on both sides of the Atlantic, their work brought to American attention through the leading English-language art magazines of the early twentieth century. One such article concerning Rusiñol in *International Studio* was entitled "A Painter of Gardens."[60]

The appearance of the floral environment, the increased concern with the flower, was not, in fact, confined to the fine arts. Floral motifs have abounded in the decorative arts from earliest times, of course,—in jewelry, wall coverings, carpets, and the like, but the upsurge of the prominence of the flower motifs in the decorative arts can be related directly to the involvement of painters and other individuals concerned with the fine arts in these other areas of aesthetic expression. The most prominent institutional development in this regard was the formation in 1879 of the Associated Artists, a partnership of Louis Comfort Tiffany, the painter Samuel Colman, Lockwood de Forest, and Candace Wheeler. Though the partnership itself lasted only four years, the organization continued under Mrs. Wheeler's direction, meanwhile having captured many prestigious commissions, private, institutional, and commercial, culminating in the redecoration of the White House, under James Garfield, in 1882.[61]

The first public commission that the group received was the drop curtain for the new Madison Square Theatre. The curtain was in place for the first play

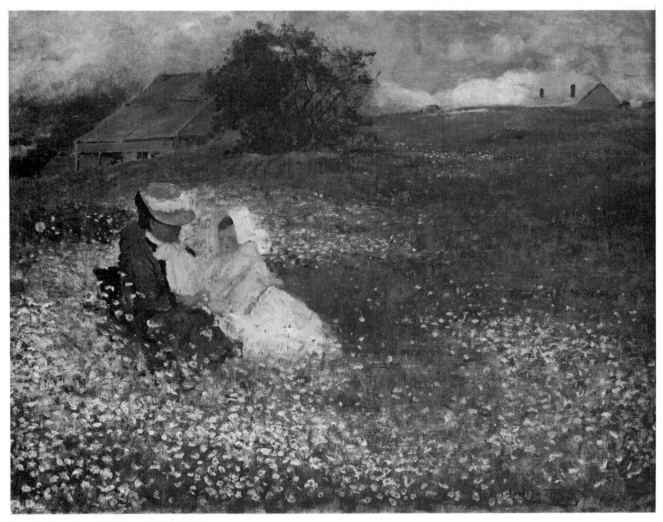

Louis Comfort Tiffany (1848–1933)
At Irvington on Hudson

performed there, *Hazel Kieke,* which opened on February 4, 1880. Though the curtain was destroyed when the theatre burned only a few months after the opening, it was a tremendous visual display seen by many and much celebrated. Tiffany adapted the design from a silk picture by Mrs. Oliver Wendell Holmes, Jr., a nature vista of woods with meadow grasses, tall wild lilies, black-eyed susans, daisies, rushes, and arrowheads, and above them, tulip trees in flower. De Forest was in charge of the materials, Colman of the color, and Wheeler of the actual execution.[62]

Other flower-involved motifs were supplied by the Associated Artists when the firm of Warren, Fuller and Co. sponsored a competition for wallpaper and ceiling designs, offering a two thousand dollar prize. Wheeler won, with a silver honeycomb superimposed with clover blossoms and bees. In 1883, Wheeler took over the firm and put emphasis upon printed cotton and silk draperies; wallpaper designs, such as her own *Consider the Lilies of the Field;* and embroidered and stitched lilies and reeds on muslin, or a cotton print design of yellow day lilies on fabric, both of 1883.

More portable, and bridging the gap between the fine and the decorative arts, were the screens of various sizes that became popular in the period and drew painters to their production. The introduction of movable screens into household design and ornamentation was a derivation from the Orient, of course, at a time of great popularity of things Chinese and Japanese. Indeed, Oriental screens appear frequently in paintings of the late nineteenth century interiors in America, as do American women in Oriental kimonos, arrangements of Oriental porcelains, and floral still lifes featuring chrysanthemums, peonies, and other Oriental flowers, just as we have seen these same flowers featured in reality in American flower shows. American artists such as Thomas Wilmer Dewing were involved in the creation of painted American screens in imitation of those made by Japanese artists and imported into America. Dewing's screens were figural, but floral motifs sometimes accompanied the figures, emphasizing the ornamental aspect of the conception and furthering the suggestion of the outdoor ambience. Patricia Gay, daughter of the artist Edward Gay, worked for Louis Tiffany's studios in New York and studied painting in that city and in Paris. In her *Hollyhocks* screen she created an exuberant piece of floral decoration, combining her pictorial abilities with the decorative inspiration first absorbed from Tiffany.

In truth, the prominence of the floral ambience in the fine and decorative arts reflects the period's vastly increased awareness of, and enthusiasm for, the garden itself, which permeated not only the arts, but life and literature also. It is no coincidence that the first ladies' garden club was established in Athens, Georgia, in 1890, at just the time that American artists were exploring

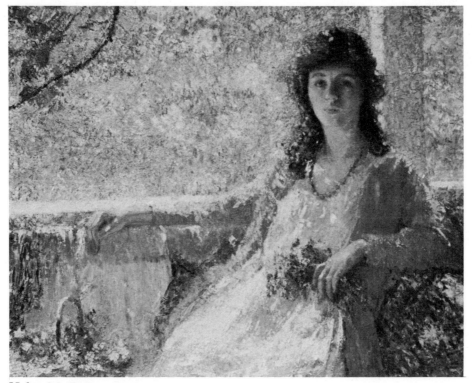

Helen M. Turner (1858–1958)
Morning, 1919

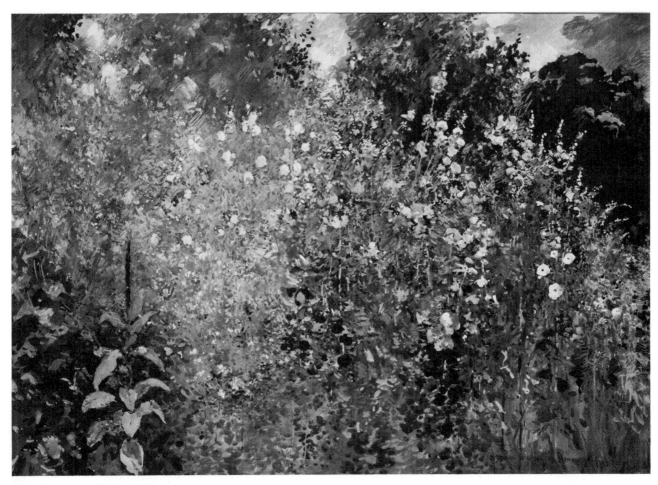

Ross Turner, (1847–1915)
A Garden is a Sea of Flowers, 1912

the garden motif with such vigor. Likewise, there was at the same time an upsurge of literature devoted to gardening. The most important new magazine on the subject was *Garden and Forest,* which started in 1888 and ran until 1897, while *Gardening* started its long run in 1892. The former was particularly significant, since one of its feature writers was Mariana Van Rensselaer, one of the foremost art and architectural critics of the time. Indeed, several of her columns in the magazine, in 1888 and again in 1893, reviewed the flower pictures exhibited at the annual exhibitions of the National Academy of Design, while in 1893 much of the material that had appeared in her *Garden and Forest* columns was recast for her seminal work on the art of gardening, *Art out-of-doors.*

This book was only one of a whole host of volumes on the subject that began to appear in the 1890s, along with dozens of periodical articles devoted to gardens, and to flowers *in situ,* generally. Occasionally these articles were written by artists, such as the Anglo-American painter, Anna Lea Merritt, whose involvement with her extensive garden in Hampshire in England led her to publish several articles in American periodicals in 1901. In one of these entitled "Making a Garden," Mrs. Merritt recognized the audience for her writing in her opening lines: "In these days of revived garden lore, when

everybody who can acquire land, whether in a window-box or in broad acres, has caught the horticultural infection . . ."[63]

Mrs. Merritt's garden advice, however, emphasized greatly the aspect of design in laying out her own Hampshire garden. To most writers and gardeners in America, this would have smacked of a more formal, English tradition. Garden literature of the time reflected the strong awareness of, and interest in, a controversy over the most suitable approach to gardening and garden layout, which has a direct bearing upon the pictorialization of the floral environment of the time. This concerned the suitability of the naturalistic, even wild garden, or alternatively, the more formal arrangements and layouts in garden design.

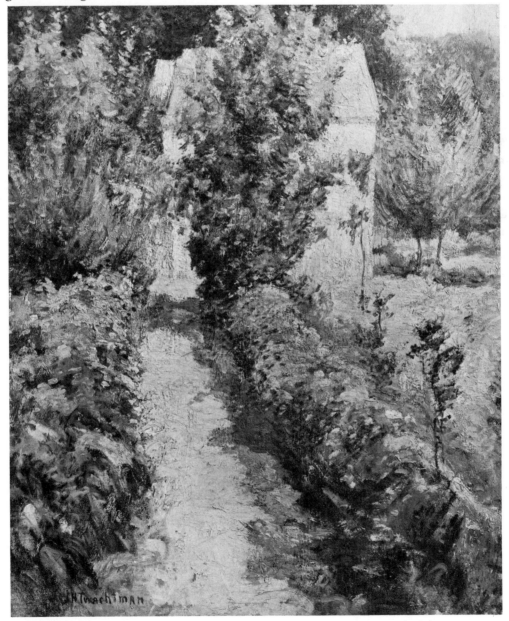

John Twachtman (1853–1902)
Azaleas, ca. 1898

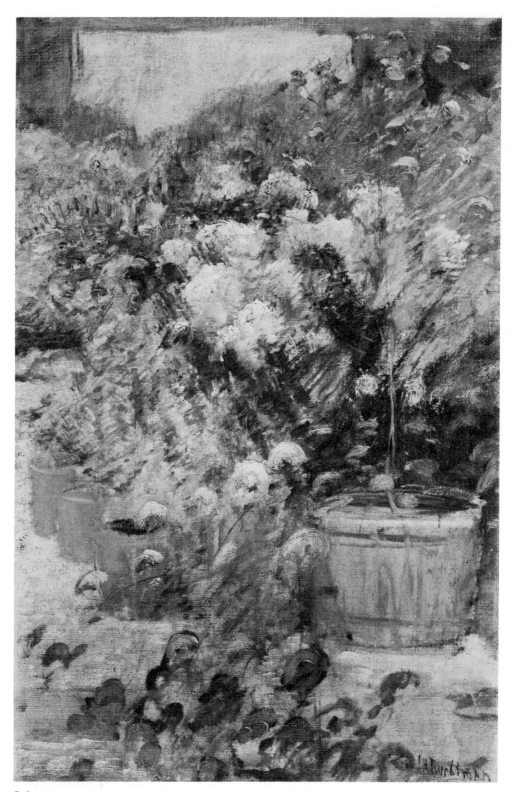

John Twachtman (1853–1902)
In the Greenhouse

The latter was sometimes championed by writers describing and acclaiming older and more traditional flower gardens; perhaps the most notable such description appeared in Alice Morse Earle's "Old Time Flower Gardens," published in 1896 with extremely beautiful illustrations by Mrs. Earle, which was elaborated in her book, *Old Time Gardens*.[64] And the formal garden received its fair share of praise in the most elaborate of all of the American garden books of the period, Guy Lowell's *American Gardens* of 1902. Although Lowell discussed the ongoing argument between the naturalistic and formalistic garden schools, and suggested that the American landscape was more suitable for naturalistic gardening, his discussion on design and composition belied his stated attitudes, for it dealt primarily with the large formal garden, and the majority of the many gardens he lavishly illustrated were those of the elite.

Some of the gardens that Lowell dealt with were, in fact, artists' gardens; four of those he described in detail were gardens in the artists' colony in Cornish, New Hampshire. Four years later, Frances Duncan published her article on "The Gardens of Cornish" in *The Century Magazine*, illustrating the gardens of artists Henry O. Walker, Augustus Saint-Gaudens, Maxfield Parrish, Kenyon Cox, Rose Nichols, Stephen Parrish, and Maria and Thomas Dewing.[65] Artists elsewhere, also, such as Louis Tiffany, otherwise so involved with the floral motif, also raised extensive gardens, so that the interplay between artistry and the flower garden was exceedingly great.[66]

Lowell's book notwithstanding, American garden literature more often tended to emphasize the informal garden, or what was referred to as the "naturalistic" approach to garden design. Indeed, Samuel Parsons, Jr., the superintendent of parks in New York City, in his 1899 book, *How to Plan the Home Grounds*, called landscape gardening the truly democratic art, and a perfect art form for the present democratic age, with a mass, rather than an elitist appeal.[67] In his earlier *Landscape Gardening*, Parsons had stated his approval of the naturalistic garden, though without rejecting the formal garden alternative, particularly the old-time gardens which had survived intact, or been reconstituted from earlier days. Basically, however, Parsons was reiterating the point of view expressed slightly earlier by George Ellwanger in *The Garden's Story* of 1889, where the author favored the naturalistic treatment of gardens, even urging clumps of natural wildness. Ellwanger noted a marked change in the previous fifteen years, with a lessening in importance of the oriental carpet of formal treatment of the garden, and a greater interest in naturalistic, hardy flower gardens.

We have noted the preference of artists of the period for the painting of uncultivated fields of flowers; even their treatment of gardens, such as Hassam's Appledore pictures, tend to emphasize the informality of the scene, allowing the exuberance of unfettered Nature to dominate. This may, of course, be seen as only reflecting the dominant garden aesthetic of the time, which it surely did, but it is also reflective both of the colorful spontaneity of that dominant pictorial Impressionist aesthetic, and of the corresponding optomistic faith in the newly achieved American cultural equality with Europe as well as her material prosperity.

In any case, the enthusiasm for the uncultivated and even the wild garden in our literature as in our art from 1890 on is marked. It is reflected in that year

John Twachtman (1853–1902)
Meadow Flowers, ca. 1890–1900

Granville Redmond (1871–1935)
California Poppy Field

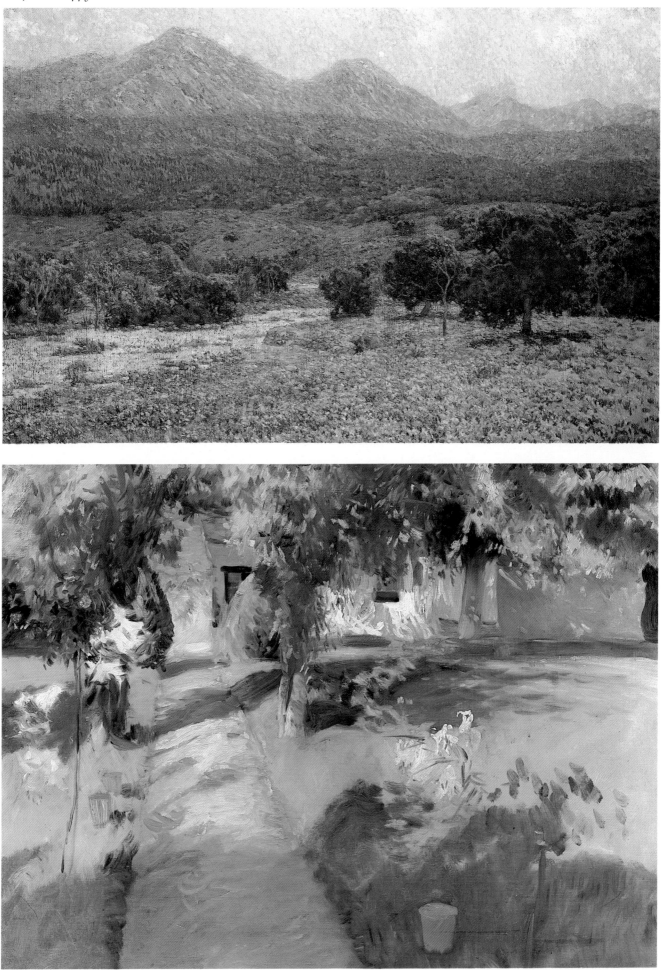

John Singer Sargent (1856–1925)
F. D. Millet House and Garden, 1886

William Trost Richards (1833–1905)
*A Summer Afternoon in a Graden in
 Philadelphia,* 1859

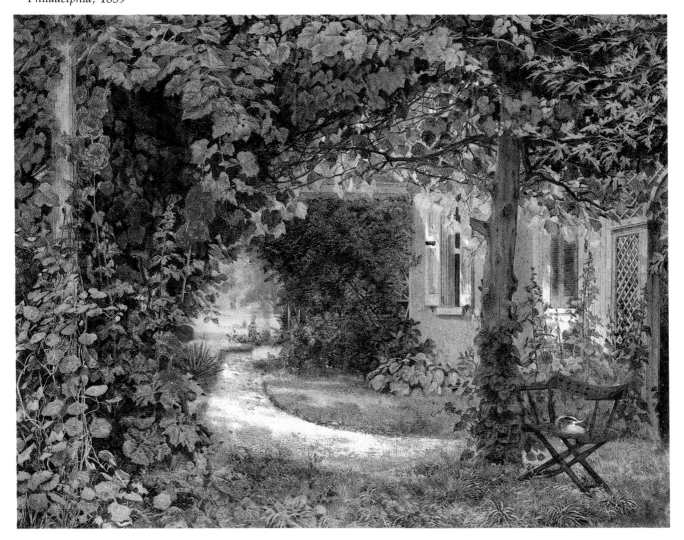

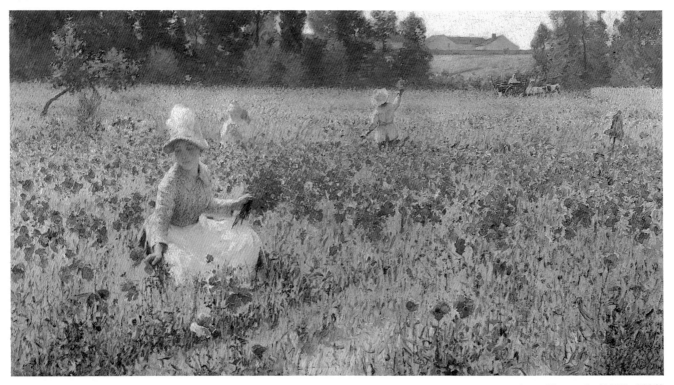

Robert Vonnoh (1858–1933)
Flanders Field, ca. 1892

John Twachtman (1853–1902)
Tiger Lillies

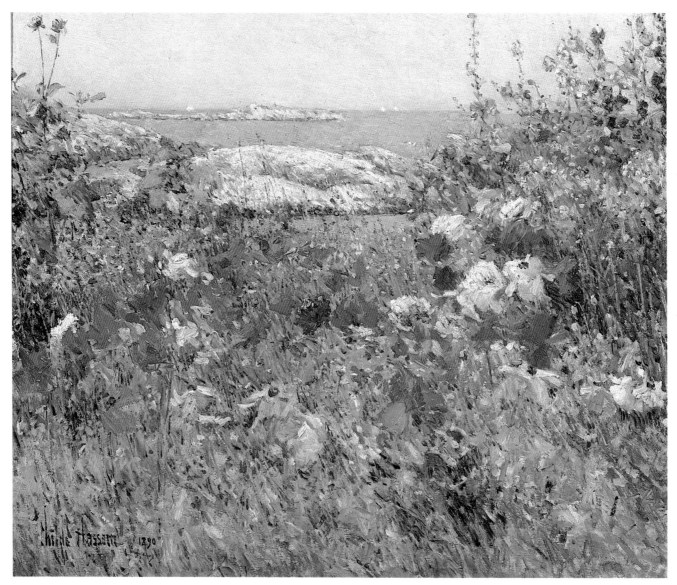

Childe Hassam (1859–1935)
Celia Thaxter's Garden, (Isles of Shoals, Maine)

John Twachtman (1853–1902)
Tiger Lillies

in "The Wild Garden," penned by William Hamilton Gibson, a leading American "Artist-Naturalist-Author," as his biographer called him, who has been likened to Thoreau and John Burroughs.[68] Coming in rapid succession, other articles espoused the uncultivated flower ambience, including Edith M. Thomas' "Notes from the Wild Garden," of 1891; F. Schuyler Matthews' piece on "Garden Flowers and their Arrangement," in 1894; two on the wild garden

that appeared in *Living Age* in 1899 and 1900; two in *Country Life in America* in 1904 and 1905, the first by J. Wilkinson Elliott on "Flowers by the Ten Thousand," and the second by Thomas McAdam on "The Gentle Art of Wild Gardening;" and Candace Wheeler's "The Decorative Use of Wild Flowers," which appeared in 1905.[69] Hers is perhaps the most eloquent statement of the dominant aesthetic of the time, reflective of such paintings as those in the present show by the two Champneys, Benjamin and J. Wells (distant cousins). Mrs. Wheeler wrote: "Not every one has a flower garden, but every one who spends even a part of the summer in the country has the freedom of the roadsides, pastures, meadow and woods; the wild gardens which belong to every man and to no man, where every one is free to gather, and there is no one to forbid."[70]

Such sentiments were to some extent anticipated by John Ruskin when he wrote, "I believe no manner of temperance in pleasure would be better rewarded than that of making our gardens gay only with common flowers; and leaving those which needed care for their transplanted life to be found in their native places when we travelled."[71] Matthews' 1894 article, mentioned above, would seem by its title to contradict the emphasis upon the wild and uncultivated which dominated the thinking of the late nineteenth century but, in fact, he quite specifically stated that "The very word arrangement, when it is connected with a flower-garden, suggests formality, to a greater or less degree. But there is such a thing as arrangement which has in it no formal element. For instance, generally speaking, the objects which an artist paints in his picture are relatively arranged, but with a studied avoidance of formality."[72]

Matthews, then, likened the design of the informal flower garden to the art of painting. But he went further. For he answered the query that he asked rhetorically: "But where is the connection between a picture and a flower garden? It seems absurd to ask the question; the garden is a picture in itself."[73]

Matthews' statement actually constitutes a summation of an attitude toward the flower garden that dominated late nineteenth century thinking and that underscored the equivalency between the garden painting and the cultivation of the painterly garden, each supportive of the other's growing popularity. The flower garden was a three-dimensional, "living" work of art; the flower gardener was him- or more often, herself, an artist, a concept that was manifestly more than hyperbole or euphemism when embodied in such a painter as Maria Dewing. Likewise, this equation seemed especially pertinent when the informal style that dominated flower gardening seemed so similar in its chromatic scale, its dependence on bright sunlight, and its soft and blurred forms, to the aesthetics of Impressionism. Undoubtedly the informality of Impressionism influenced the naturalistic direction of contemporary garden design, just as that design was reflected in Impressionist garden pictures, but this interrelationship, itself, underscored the acceptability of flower gardening as a sister art.

In a sense, such a concept was not new, since landscape gardening had for centuries been accepted as an art form, and had been acknowledged much earlier in the nineteenth century in America. Andrew Jackson Downing as early as 1841, in his seminal treatise on landscape gardening in America pointed out that "Again and again has it been said that Landscape Gardening

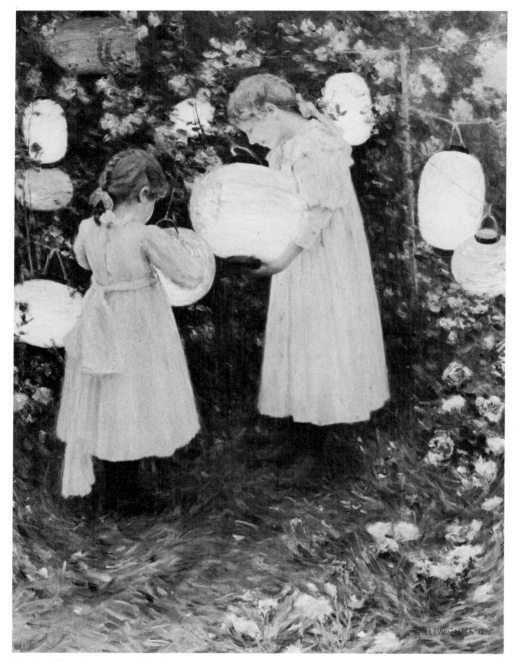

Luther Emerson van Gorder
 (1861–1931)
Japanese Lanterns, 1895

and Painting are allied." And Edward C. Bruce in an article on "American Landscape Gardening" in 1879 noted that "Landscape-Painting furnishes the chief type of American pictorial art. Landscape-making is a sister branch . . ."[74] However, the concept of the flower garden specifically as a work of art developed at the end of the century and not surprisingly was almost always linked to Impressionist painting. In her book, *The Rescue of an Old Place*, Mary Caroline Robbins, in 1892, described the reconditioning of an old Hingham,

Massachusetts farmstead, and when referring to the laying out of the garden, she likened it to the painting of a picture, specifically referring to Impressionism in doing this, each new planting equated with a dab of paint.[75] Mariana Van Rensselaer prepared the aforementioned *Art out-of-doors* published in 1893 for the World's Columbian Exposition in Chicago, hoping that the fair would publicize the art of gardening as the fourth art of design, along with architecture, sculpture, and painting. She agreed with the belief of the time, that landscape gardening involved the creation of three-dimensional pictures, and went further in stating that while landscape gardeners may have learned from poets and painters, it is not the role of the gardener to celebrate their work, but that of the poet and the painter to celebrate his.[76]

The clearest alliance between the gardener and the painter was stated by Beatrix Jones in her 1907 article entitled, appropriately enough, "The Garden as a Picture." In this she wrote that: "The two arts of painting and garden design are closely related, except that the landscape gardener paints with

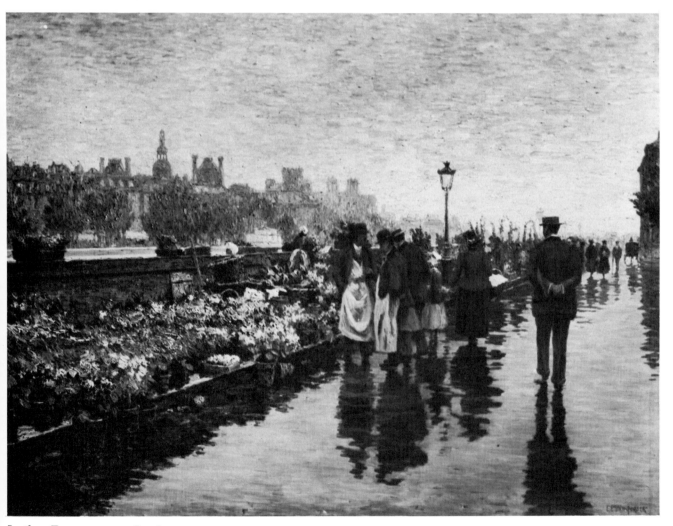

Luther Emerson van Gorder
(1861–1931)
Quai aux Fleurs, Paris

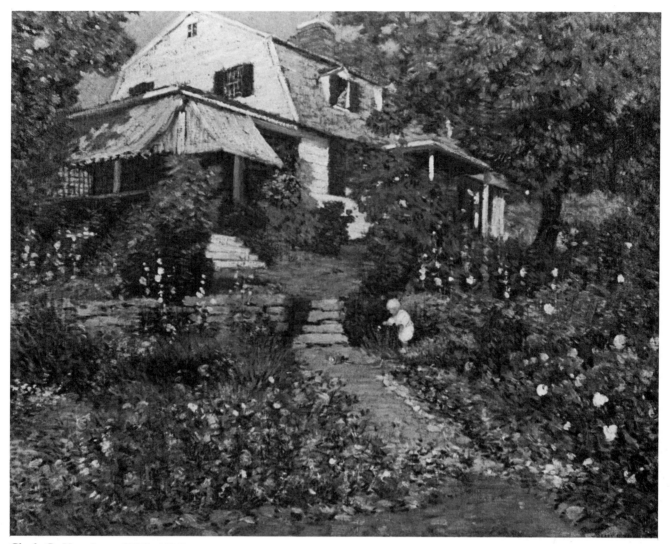

Clark G. Voorhees (1871–1933)
My Garden, ca. 1914

actual color, line, and perspective to make a composition, as the maker of stained glass does, while the painter has but a flat surface on which to create his illusion; he has, however, the incalculable advantage that no sane person would think of going behind a picture to see if it were equally interesting from that point of view." She later noted that "A garden, large or small, must be treated in the impressionist manner."[77] The contemporary work of Hugh Breckenridge comes almost immediately to mind!

Mariana Van Rensselaer likened the creation of the garden to the celebrations of poets and painters. And indeed, images and the ambience of the floral environment are also pervasive in contemporary imaginative literature. Garden settings can be found in many a novel and short story, but the flower garden and fields of flowers are especially abundant in poetry. This was a tradition through the ages, of course, hardly limited to the late nineteenth and early twentieth centuries, and if one considers the writing of the most famous poet of the generation just prior to the period under discussion, the En-

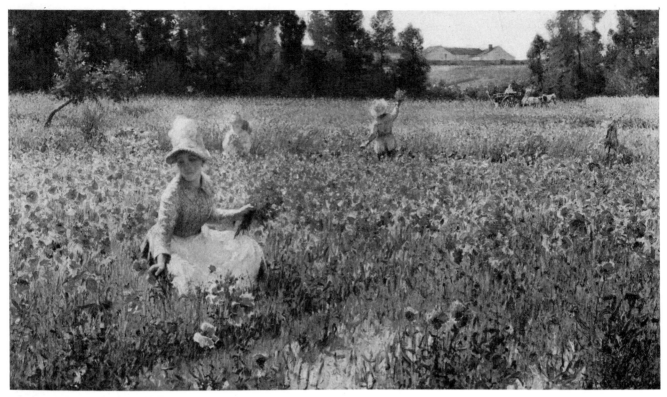

Robert Vonnoh (1858–1933)
Flanders Field, ca. 1892

glishman, Alfred Lord Tennyson, one finds an oeuvre replete with botanical imagery, from "Come into the garden, Maud. . . ." on through all his flower-suffused work.

American poets took naturally to garden imagery, which in turn, reflected the art of the period, two faces of a single coin, and each honoring that fourth art of garden design. Celia Thaxter, herself, was a noted poet, and while *An Island Garden* is a work of prose, a great many of her poems are enriched with floral imagery or are devoted to the subject of the flower garden. Here, for instance, is an excerpt from "My Garden" by Mrs. Thaxter:

> It blossomed by the summer sea
> A tiny space of tangled bloom
> Wherein so many flowers found room
> A miracle it seemed to be.
>
> And tall blue larkspur waved its spikes
> Against the sea's deep violet
> That every breeze makes deeper yet
> With splendid azure where it strike.[78]

Floral imagery pervades, too, much of the writing of the Imagist poets of the early years of the twentieth century, a later group—more contemporary with the work of Frieseke, for instance, as Mrs. Thaxter's is of Hassam's

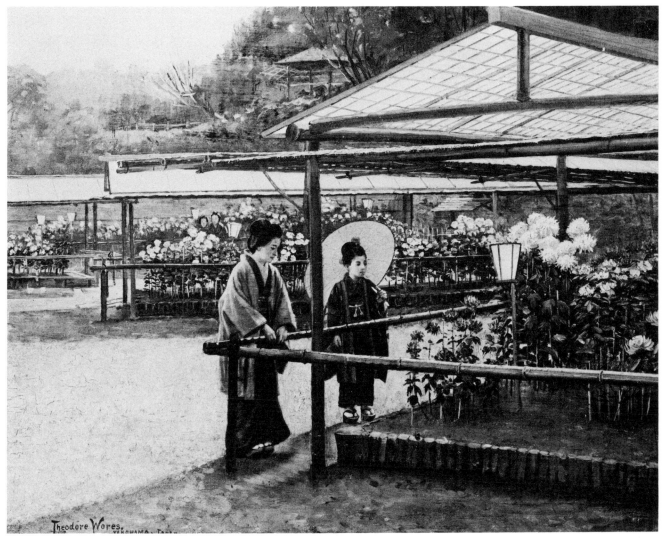

Theodore Wores (1859–1939)
Chrysanthemum Show, Yokohama

painting—and in a way, the Imagist poems and Frieseke's pictures are some-what more earth-bound, more specific and less romantic than the generalized, idyllic imagery of Thaxter and Hassam. The floral, and particularly the garden motif figures strongly in the Imagist poems of Amy Lowell especially. See, for example, the first stanza of her famous poem, "Patterns" of 1915.

> I walk down the garden-paths,
> And all the daffodils
> Are blowing, and the bright blue squills.
> I walk down the patterned garden-paths
> In my stiff, brocaded gown.
> With my powdered hair and jeweled fan,
> I too am a rare
> Pattern. As I wander down
> The garden-paths.[79]

Such a memorable literary image calls to mind, for instance, Frieseke's *Hollyhocks* of a similar date. "Patterns," however, has a sharp and biting edge, for beyond its slightly self-mocking image of precious patterns is related the stunning reproach of reality in the death of a lover, killed in the war. But such narrative denouments do not inform all of Amy Lowell's work by any means, and a more direct literary transcription of our pictorial imagery can be seen in her poem, appropriately entitled, "Impressionist Picture of a Garden":

> Give me sunlight, cupped in a paint brush
> And smear the red of peonies
> Splash blue upon it,
> The hard blue of Canterbury bells,
> Paling through larkspur
> Into heliotrope,
> To wash away among forget-me-nots
> Dip red again to mix a purple,
> And lay on pointed flares of lilac against bright green.
> Streak yellow for nasturtiums and marsh marigolds
> And flame it up to orange for my lilies.
> Now do it so—and so—along an edge of Iceland poppies.
> Swirl it a bit, and faintly,
> That is honeysuckle.
> Now put a band of brutal, bleeding crimson
> And tail it off to pink, to give the roses.
> And while you're loading up with pink,
> Just blotch about that bed of phlox.
> Fill up with cobalt and dash in a sky
> As hot and heavy as you can make it;
> Then tree-green pulled up into that
> Gives a fine jolt of colour.
> Strain it out,
> And melt your twigs into the cobalt sky.
> Toss on some Chinese white to flash the clouds,
> And trust the sunlight you've got in your paint.
> There is a picture.[80]

In American nineteenth century literature, the flower was much written about as an object of beauty, even as a symbol of God's grace, and in fact, in his famous essay on "Flowers" published in 1850, Henry T. Tuckerman deplored the formalized association of flowers with science and with sentiment—the proliferation of botanical studies or "language of flower" books so vastly popular at the mid-century. Tuckerman lay stress, rather, on "The spirit of beauty," which as he said, "in no other inanimate embodiment, comes so near the heart." Tuckerman spoke of flowers as "the most unobjectionable and welcome of gifts . . . They are radiant hieroglyphics, sculptured on the earth's bosom; perhaps the legacy of angels. . . ."[81] Also at mid-century, Ralph Waldo Emerson, too, echoed those sentiments when he said that "Flowers and fruits are always fit presents. Flowers because they are a proud assertion that a ray of beauty outvalues all the utilities of the world."[82]

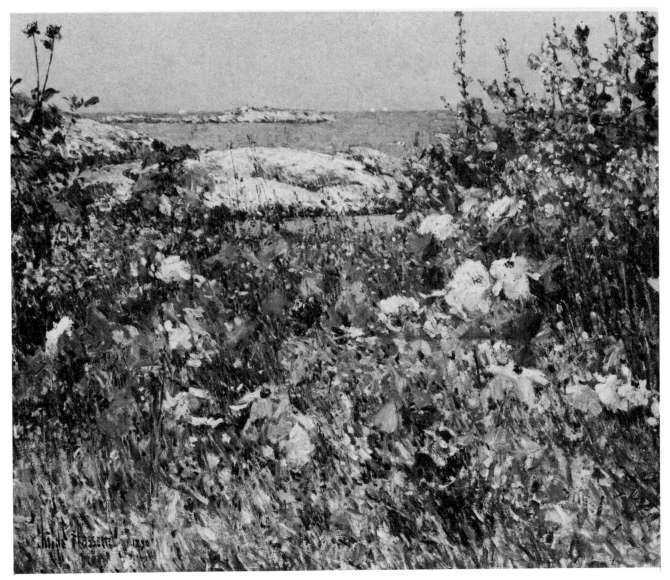

Childe Hassam (1859–1935)
Celia Thaxter's Garden, (Isles of Shoals,
Maine)

For Tuckerman and for Emerson, as for the American painter at mid-century, it was the individual flower which offered its reward, whether as an element of beauty in a still life, a hieroglyph of heaven, an offering of affection, just as for the writer of contemporary popular literature the flower constituted a botanical specimen or a sentimental symbol. But in the later nineteenth century, and on into the twentieth, the individual flower was subsumed into the whole of its environment, and it was that floral ambience that constituted the effective inspiration, a moral climate of beauty and of assurance, from which artists and writers derived so much inspiration.

Throughout this essay, the figure of Candace Wheeler has appeared several times, as an innovator in the decorative arts in America, as writer of garden books, and as a member of the creative elite, a friend of artists, writers and critics. Her involvement with the arts went further, for she was an occasional

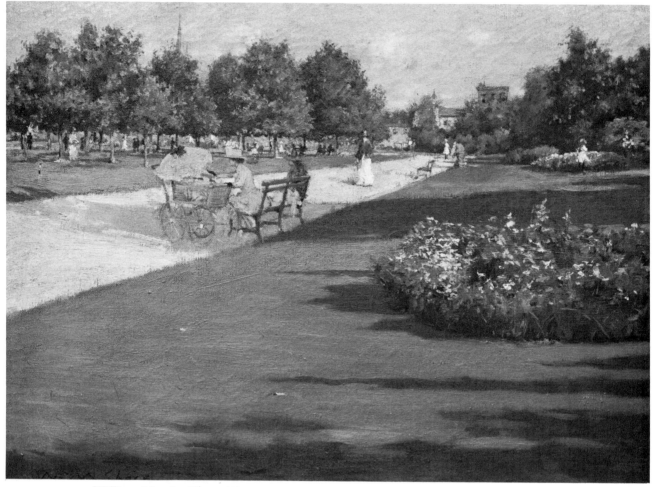

William Merritt Chase (1849–1916)
Prospect Park, Brooklyn

art critic, writing, for instance, about floral still lifes. She was also one of the founders of the Onteora colony in the Catskills where she first went in 1883, a prime figure in memorializing and honoring our earliest native school of landscape painters who worked in the region.[83] Let us listen to Candace Wheeler in the articles that she published in the *Atlantic Monthly* in 1900, and elaborated into book form in 1901, retaining the title "Content in a Garden":

> My Garden of Content lies high on Onteora Mountain . . . When I began to dig and plant, I little knew the joy which would grow out of the soil, and descend from the skies, and gather from far-off places and times to gladden my soul; but today, as I walk therein, or sit in the spicy shadow of its pair of fir trees, and think what it has done for me, I feel that untroubled happiness begins and ends within it; that it is truly the Land of Content.[84]

That was, in fact, the meaning and the message of the floral environment.

These pictures of gardens and fields of flowers—radiant in brilliant colors under the glowing warmth of sunshine—transmitted a message of spiritual warmth, of reassurance. These were more than statements of fact, more than observations of horticultural success; for the realm they depicted was the Land of Content.

NOTE

The following reproductions represent paintings which are not in the exhibition, but which are mentioned in the text:

Alice Morse Earl
Old Time Flower Gardens

Childe Hassam (1859–1935)
The Room of Flowers

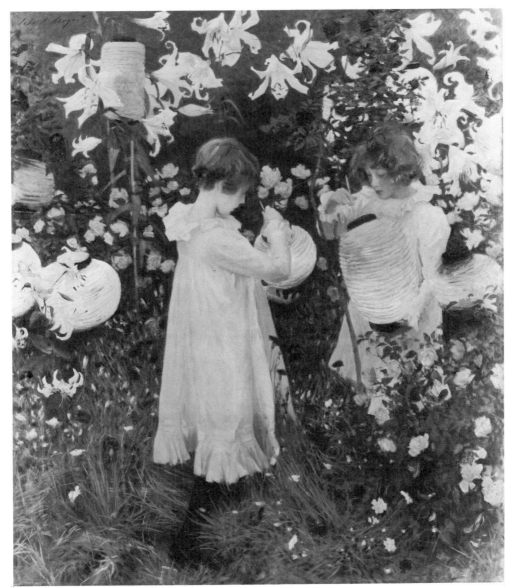

John Singer Sargent (1856–1925)
Carnation, Lily, Lily, Rose

Eastman Johnson (1824–1906)
Hollyhocks

Guy Lowell
American Gardens

Notes

1. While the number of paintings devoted to our theme is enormous, the literature concerning the subject is almost nonexistent. Such pictures figure often in monographic studies and are featured in explorations of aesthetic trends, but as a separate theme, scholars have tended to ignore the floral environment. In part, this has occurred because of the concentration of these pictures within the Impressionist aesthetic, which aesthetic itself, until very recently, has been explored more for its formal, stylistic interest, than for thematic concerns. For the subject, see Miles and John Hadfield, *Gardens of Delight*, Boston and Toronto, 1964, and more recently, the articles: David Bourdon, "Art: Painting of Gardens," *Architectural Digest* 37 (June 1980): 70–75; and William H. Gerdts, "The Artist's Garden," *Portfolio* 4 (July/August 1982): 44–51. For the European equivalent of the American garden picture, see the catalogue, *Birds, Bees, and Gardens: Romantic Visions of Victorian England*, Hirschl & Adler Galleries, New York City, April 21–May 27, 1983, with an essay by Christopher Wood.

2. The peasant garden was especially a garden in which cabbages (or kale) was grown. The symbolism of this specific vegetable as a life staple for the lower agrarian class needs exploration, both sociological and artistic. It was a common theme in European art, both on the continent and in Scotland, and not unknown in the United States. See among others, Thomas Anshutz, *The Cabbage Patch* of 1879 (Metropolitan Museum of Art).

3. For some of Ruskin's attitudes toward the outdoor nature study and still life, see his "Academy Notes, 1857," *The Complete Works of John Ruskin*, eds. E. T. Cook and Alexander Weddeburn, London, 1905, vol. 14, p. 116; *Modern Painters*, London, 1856, vol. 3, p. 18; *Praeterita*, Orpington and London, 1899, vol. 2, p. 300. The author deals with the subject at length in "The Influence of Ruskin and Pre-Raphaelitism on American Still Life Painting," *The American Art Journal* 1 (Fall 1969): 80–97.

4. H. Buxton Forman, "An American Studio in Florence," *The Manhattan* 3 (June 1884): 533.

5. Forman, 533–534.

6. James Jackson Jarves, *The Art-Idea*, 1864, new edition, ed. Benjamin Rowland, Jr., Cambridge, 1960, 204–205; and Royal Cortissoz, *John La Farge: A Memoir and a Study*, Boston and New York, 1911, 135–136.

7. Anne H. Wharton, "Some Philadelphia Studios," *The Decorator and Furnisher*, 7, December, 1885, 78.

8. Susan Paulette Casteras, "Down the Garden Path: Courtship Culture and its Imagery in Victorian Painting," Yale University Ph.D. dissertation, 1977.

9. F.D.H., "Hovey's Monthly Magazine of Horticulture," a review in *Christian Examiner*, 31, September, 1841, 69; the reviewer reiterates the popular attitude of gardening as one of the fine arts, see 67.

10. Patricia Hills, *Eastman Johnson*, New York, 1972, 79.

11. Letter from Professor Herbert at Yale University to the author, April 21, 1982. I am tremendously indebted to Professor Herbert, Professor Steven Z. Levine of Bryn Mawr College, and Professor Joel Isaacson of the University of Michigan, all of whom are Monet scholars who took much time and trouble to answer my inquiries concerning Monet's garden pictures. All of them came also to the same conclusions, that this phase of the artist's oeuvre was lacking in comprehensive study and in need of it. Compared to much of the artist's oeuvre, both his pre- and early Impressionist painting, and the serial work he did from the late '80s on, including the later garden water lily paintings, the garden and flower field pictures of the '70s and early to mid-'80s have been critically and historically neglected. Professor Levine provided what bibliography there is on such works, but he agreed that, with the exception of the essay by Mrs. Michael (See essay and note 17), the material is not substantial.

12. Edwin H. Blashfield, "John Singer Sargent—Recollections," *North American Review*, 221, June 1925, 643–644. Luther van Gorder's *Japanese Lanterns* of 1895, in the present exhibition, is an affectionate imitation and a tribute to the renown of *Carnation, Lily, Lily, Rose*, painted a decade later.

13. T., "Country Homes & Gardens Old & New: The Abbot's Grange, and Russell House, Broadway, Worcestershire, the Residence of Mr. F. D. Millet," *Country Life*, 29, January 14, 1911, 54–61.

14. There is some confusion as to exactly who and exactly when Americans first visited Giverny. Probably as accurate as any is the account of "The Real Story of Giverny" by Dawson Dawson-Watson, appended to Eliot C. Clark, *Theodore Robinson, His Life and Art*, Chicago, 1979, 65–67.

15. Hamlin Garland, *Roadside Meetings*, New York, 1930, 30–31.

16. *The Art Interchange*, 44, December 1900, 136.

17. Celin Sabbrin (pseud. for Helen De Silver Michael), *Science and Philosophy in Art*, Philadelphia, 1886. I am tremendously indebted to my good friend and colleague, Frances Weitzenhoffer who has worked extensively in this area of French and American art, while researching her dissertation on the Havemeyer collection. Dr. Weitzenhoffer has also lectured on the early works of Monet shown and acquired in America, and it is she who brought Mrs. Michael's disquisition to my attention. The results of Dr. Weitzenhoffer's studies of Monet, from which much of this section of my essay is drawn, will be published shortly.

18. *op. cit.*, 6–7.

19. Etienne Moreau-Nelaton, *Histoire de Corot et de ses oeuvres*, Paris, 1905, 336.

20. Sabbrin, *op. cit.*, 17.

21. *op. cit.*, 19.

22. See, for instance, Robert Herbert, "Method and Meaning in Monet," *Art in America*, 67, September 1979, 90–108.

23. Steven Z. Levine, *Monet and his Critics*, New York and London, 1976, 67–68.

24. Sabbrin, *op. cit.*, 18.

25. Mrs. Schuyler Van Rensselaer, "The French Impressionists," *The Independent*, 523, April 29, 1886, 7–8.

26. F. Hopkinson Smith, *Between the Extremes*, Brooklyn, 1888, 22–23.

27. *National Cyclopedia of American Biography*, 7, 1897, 462.

28. I am indebted to May Brawley Hill for the conclusions reached concerning Vonnoh's *Poppies*. Unfortunately, the dating of the picture has become woefully confused by the artist's later retitling of the picture as *In Flanders Field*, capitalizing on the sentiments born of the early conflicts of World War I, and the popular poem by John McCrae. The picture therefore acquired the aberrant date of ca. 1914, obviously irreconcilable with the costumes of the figures. The picture once bore the date "1890" as indicated in an 1892 photograph which Mrs. Hill has kindly shown me.

29. Charles C. Curran, "The Outdoor Painting of Flowers," *Palette and Bench*, 1, July 1909, 217.

30. *Palette and Bench*, 1, December 1908, 51.

31. The primary studies of Celia Thaxter and her Isles of Shoals gardens are Celia Thaxter, *An Island Garden*, Boston and New York, 1894; Celia Thaxter, *The Heavenly Guest*, Andover, 1935; Frank Preston Stearns, *Sketches from Concord and Appledore*, New York and London, 1895, 223–252; and Rosamond Thaxter, *Sandpiper: The Life of Celia Thaxter*, Sanbornville, New Hampshire, 1962. See also the essays by Alice Downey and Peter Bermingham in *A Stern and Lovely Scene: A Visual History of the Isles of Shoals*, exhibition catalogue, University Art Galleries, University of New Hampshire, Dublin, 1978.

32. Ellen Robbins, "Reminiscences of a Flower Painter," *New England Magazine*, 14, June 1896, 440–451, and July 1896, 532–545, esp. 534–535.

33. Thaxter, *Heavenly Guest*, 119–120.

34. Candace Wheeler, *Content in a Garden*, Boston and New York, 1901, 56–57.

35. Thaxter, *Heavenly Guest*, 129–130.

36. *op. cit.*, 126.

37. Thaxter, *Island Garden*, 50.

38. *op. cit.*, 79.

39. *op. cit.*, 81.

40. *loc. cit.*

41. Quoted from Royal Cortissoz, "An Artist Made Better Known since his Death," in the *New York Tribune*, November, 1916, in Ronald G. Pisano, *G. Ruger Donoho*, exhibition catalogue, Hirschl & Adler Galleries, New York City, 1977, n.p.

42. Jennifer Martin Bienenstock has written extensively on Maria Dewing; see especially (as Jennifer A. Martin), "The Rediscovery of Maria Oakey Dewing," *The Feminist Art Journal*, 5, Summer 1976, 24–27, 44; and (as Jennifer Martin Bienenstock), "Portraits of Flowers: The Out-of-Door Still-Life Paintings of Maria Oakey Dewing," *American Art Review*, 4, December 1977, 48–55, 114–118.

43. Maria Oakey Dewing, "Flower Painters and What the Flower Offers to Art," *Art and Progress*, 6, June 1915, 262.

44. Quoted by Bienenstock, "Out-of-Door. . . .," *op. cit.*, 114, from an interview with Nelson C. White, Spring 1976.

45. Arthur Edwin Bye, *Pots and Pans or Studies in Still-life Painting*, Princeton and Oxford, 1921, 199, the first American-authored study of still life, wherein there is a substantial American section, and in which Maria Dewing is lauded as the finest American woman specialist.

46. Heliogabalus was a Roman Emperor (reigned 218–222) said to be the natural son of the Emperor Caracalla. He lived a life of debauchery and extravagance; he is said to have perfumed his orgies with myriads of roses and rose petals released upon the participants, some of whom are described as suffocating beneath the flowers.

47. *The Art Interchange*, 42, May 1899, 115.

48. George Alfred Williams, "A Painter of Colorful Gardens," *International Studio*, 76, January, 1923, 304–309.

49. Samuel A. Wood, "Flower Shows in the United States," *Chautauquan*, 15, May 1892, 180–183.

50. Wores' article on "The Chrysanthemum in Japan," appeared in *Harper's Weekly*; its date is not known. He also published several articles on "Flowers in Japan," in *Garden and Forest* in September 1888, and one on "Japanese Flower Arrangement," in *Scribner's Magazine* in August 1899. A full list of Wores' writings on Japan is appended to Joseph A. Baird, Jr., *Theodore Wores, The Japanese Years*, exhibition catalogue, The Oakland Museum, 1976.

51. Clara T. MacChesney, "Frieseke Tells Some of the Secrets of his Art," *The New York Times*, June 7, 1914, section 6, 7.

52. Elizabeth Bisland, "The New York Flower Market," *Cosmopolitan*, 8, December 1889, 202.

53. "Hovenden," *The Art Interchange*, 6, Feb. 17, 1881, 34.

54. See for instance, Christian Brinton, "George Hitchcock—Painter of Sunlight," *International Studio*, 26, July 1905, i–vi; Charles Henry Meltzer, "A Painter of Sunlight," *Hearst's Magazine*, 22, July 1912, 131–134; this reference reappears in Aileen Ham-

mond, "George Hitchcock—Painter of Sunlight," *Spinning Wheel,* October 1974, 12–13.

55. Guy Pene du Bois, "George Hitchcock, Painter of Holland, *Arts and Decoration,* 3, October 1913, 403–404.

56. Meltzer, *op. cit.,* 132–134.

57. C. F. Holder, "Copa de Oro," *Land of Sunshine,* 1, June 1894, 5; James George Wharton, *California Romantic and Beautiful,* Boston, 1914, 272.

58. *Academy Notes,* 3, February, 1908, 150.

59. See the many examples of garden pictures included in the important exhibition, *Connecticut and American Impressionism,* Storrs, Greenwich and Old Lyme, Connecticut (a three-part exhibition), 1980.

60. Vittorio Pica, "A Painter of Gardens: Santiago Rusiñol," *International Studio,* 32, August 1907, 98–103; and "G. W.," "The Garden and its Art, with Especial Reference to the Paintings of G. S. Elgood," *Studio,* 5, May 1895, 51–56. Elgood was included in the *Birds, Bees, and Gardens* exhibition, cited in footnote 1.

61. For information on the Associated Artists and its commissions, see Wilson H. Faude, "Associated Artists and the Amercian Renaissance in the Decorative Arts," *Winterthur Portfolio* 10, 1975, 101–130.

62. Faude, *op. cit.,* 105–106.

63. Anna Lea Merritt, "Making a Garden," *Lippincott's,* 67, March 1901, 353; see also her article, "My Garden (A Hamlet in Old Hampshire)," *Century Magazine,* 62, July 1901, 342–351.

64. Alice Morse Earle, "Old Time Flower Gardens," *Scribners Magazine,* 20, August 1896, 161–178.

65. Frances Duncan, "The Gardens of Cornish," *Century Magazine,* 72, May 1906, 3–19. See also her article on Stephen Parrish's garden, "An Artist's New Hampshire Garden," *Country Life in America,* 11, March 1907, 516–520, 554, 556, 558.

66. Samuel Howe, "The Garden of Mr. Louis C. Tiffany," *House Beautiful,* 35, January 1914, 40–42.

67. Samuel Parsons, Jr., *How to Plan the Home Grounds,* New York, 1899, 54–55.

68. W. Hamilton Gibson, "The Wild Garden," *Harper's New Monthly Magazine,* 81, September 1890, 622–631. On Gibson, see John Coleman Adams, *William Hamilton Gibson, Artist-Naturalist-Author,* New York and London, 1901.

69. Edith M. Thomas, "Notes from the Wild Garden," *Atlantic Monthly,* 68, August 1891, 172–178; F. Schuyler Matthews, "Garden Flowers and their Arrangement," *Garden and Forest,* 7, June 27, 1894, 252–253; "In Nature's Wild Garden," *Living Age,* 223, December 2, 1899, 590–592, and "The Wild Garden," *Living Age,* 225, April 21, 1900, 137–144; J. Wilkinson Elliott, "Flowers by the Ten Thousand," *Country Life in America,* 6, September 1904, 404–409; Thomas McAdam, "The Gentle Art of Wild Gardening," *Country Life in America,* 7, March 1905, 470–473; Candace Wheeler, "The Decorative Use of Wild Flowers," *Atlantic Monthly,* 95, May 1905, 630–634.

70. Wheeler, "Decorative Use . . ." *op. cit.,* 630.

71. John Ruskin, *Proserpina, Studies of Wayside Flowers,* 2 volumes, Orpington, 1879, 2, 451.

72. Matthews, *op. cit.,* 252.

73. Matthews, 252.

74. Andrew Jackson Downing, *A Treatise on the Theory and Practice of Landscape Gardening, Adapted to North America,* 1841; 6th edition, New York, 1859, 56. (This edition is recommended for its updated supplement written by Henry Winthrop Sargent); Edward C. Bruce, "American Landscape-Gardening," *Lippincott's,* 24, October 1879, 484.

75. Mary Caroline Robbins, *The Rescue of an Old Place,* Boston and New York, 1892, 132–33 with reference specifically to Monet.

76. Mrs. Schuyler Van Rensselaer, *Art out-of-doors: Hints on good taste in gardening,* New York, 1893, 359–360.

77. Beatrix Jones, "The Garden as a Picture," *Scribner's Magazine,* 42, July 1907, 2, 6.

78. Quoted in Thaxter, *The Heavenly Guest,* op. cit., 124.

79. Quoted from *The Complete Poetical Works of Amy Lowell,* Cambridge, 1955, 75.

80. *op. cit.*, 222. First published in *The Trimmed Lamp*, 5, April 1916, 181.

81. Henry T. Tuckerman, "Flowers," *Godey's Ladies Book*, 40, January 1850, 13–18.

82. Quoted by Candace Wheeler, "Content in a Garden II," *Atlantic Monthly*, 86, July 1900, 99.

83. For Candace Wheeler, see her autobiography, *Yesterdays in a Busy Life*, New York and London, 1918.

84. Candace Wheeler, "Content in a Garden I," *Atlantic Monthly*, 85, June 1900, 779.

Catalogue of the Exhibition

MONTCLAIR ART MUSEUM
Montclair, New Jersey
October 1–November 30, 1983

TERRA MUSEUM OF AMERICAN ART
Evanston, Illinois
December 13, 1983–February 12, 1984

HENRY ART GALLERY
University of Washington
Seattle, Washington
March 1–May 27, 1984

Abraham Archibald Anderson
(1847–1940)
French Cottage, 1883
oil on canvas, 18 × 24
The Newark Museum

Karl Anderson (1874–1956)
Wisteria, 1915
oil on canvas, 29 × 27
National Academy of Design,
New York

Gifford Beal (1879–1956)
The Garden Party, 1920
oil on canvas, 18¹⁄₁₆ × 24¹⁄₁₆
The Phillips Collection

Albert Bierstadt (1830–1902)
Field of Red and Yellow Wildflowers
oil on paper laid on canvas,
 13¼ × 18⅞
Davis & Langdale Company, New York

Franz A. Bischoff (1864–1929)
Peonies
oil on canvas, 30 × 40
Dr. and Mrs. Marvin Kantor

Robert Frederick Blum (1857–1903)
The Flower Market, Tokyo, ca. 1891
oil on canvas, 31⅝ × 25⅜
Private Collection, Courtesy of James
 Maroney, New York

Edward Darley Boit (1840–1915)
Flower Pots on the Terrace, Cernitoia, 1902
watercolor on paper, 9¹³⁄₁₆ × 13¹⁵⁄₁₆
Courtesy of Jeffrey R. Brown, Fine
 Arts, Inc.

John Leslie Breck (1860–1899)
Garden at Giverny, ca. 1887
oil on canvas, 18 × 22
Private Collection, Courtesy of
Berry-Hill Galleries, New York

Hugh Henry Breckenridge (1870–1937)
The Flower Garden, 1906
oil on canvas, 25 × 30
Warren P. Synder, Courtesy of
R. H. Love Galleries, Inc., Chicago

Fidelia Bridges (1834–1924)
Thrush and Field Flowers, 1874
watercolor, 14 × 10
Dr. and Mrs. Harry Cohen, New York

133

J. Appleton Brown (1844–1902)
Celia Thaxter's Garden—Isle of Shoals,
ca. 1891
pastel on paper, 18 × 21¾
Roland and Ester Pineault Fine Arts,
 Holyoke, Massachusetts

George Brainerd Burr (1876–1939)
Old Lyme Garden
oil on panel, 12 × 9
Lyme Historical Society

Theodore Butler
The Blue Tree
oil on canvas, 23½ × 28½
Private Collection
Courtesy of Galerie le Mire
New Orleans, Louisiana

Benjamin Champney (1817–1907)
The Artist's Studio
oil on canvas, 21 × 17
Private Collection

J. Wells Champney (1843–1903)
Garden in Old Deerfield
gouache on paper, 15⅛ × 10¾
Private Collection, Courtesy of
Jeffrey R. Brown, Fine Arts, Inc.

William Merritt Chase (1849–1916)
Prospect Park, Brooklyn
oil on canvas, 17⅜ × 22⅜
Colby College Museum of Art,
Gift of Miss Adeline F. and Miss
 Caroline R. Wing

Frederic Edwin Church (1826–1900)
Jamaican Flowers, 1865
oil on paperboard, 13⅝ × 15⅝
The Cooper-Hewitt Museum,
The Smithsonian Institution's
National Museum of Design
 (1917-4-679A)

Charles C. Curran (1861–1942)
Rhododendron Bower, 1920
oil on canvas, 30 × 30
Frederic and Maureen Radl

Charles C. Curran (1861–1942)
Delphiniums Blue
oil on canvas, 30¼ × 25⅛
Anthony B. Christensen

Charles C. Curran (1861–1942)
Lotus Lilies, 1888
oil on canvas, 18 × 21
Daniel J. Terra Collection
Terra Museum of American Art

Edwin Deakin (1838–1923)
Homage to Flora, 1903–04
oil on canvas, 36 × 30
Private Collection

Maria Oakey Dewing (1857–1927)
Bed of Poppies, 1909
oil on canvas, 25 × 30
Addison Gallery of American Art
Phillips Academy, Andover,
 Massachusetts

Maria Oakey Dewing (1857–1927)
Garden in May, 1895
oil on canvas, 23⅝ × 32½
National Museum of American Art,
Smithsonian Institution,
Gift of John Gellatly

William Dodge (1867–1935)
Nun in Giverny Gardens
oil on canvas, 72¾ × 40¼
Private Collection

G. Ruger Donoho (1857–1916)
Windflowers
oil on canvas 30 × 36
The Metropolitan Museum of Art
Rogers Fund, 1917

John J. Enneking (1841–1916)
Rose Garden, 1880
oil on canvas, 22¼ × 18¼
Sheila W. and Samuel M. Robbins,
Newton, Massachusetts

Frederick Carl Frieseke (1874–1939)
Lady in a Garden, ca. 1912
oil on canvas, 31 × 26½
Daniel J. Terra Collection
Terra Museum of American Art

Patricia Gay (1878–1965)
Hollyhock Screen
4 panel floor screen with gold tea leaf
each panel 20 × 64
paper-painted oil on wood
Miss Mary Reed Johnson

Abbott Fuller Graves (1859–1936)
Near Kennebunkport, ca. 1895–1900
oil on canvas, 18 × 27
Mr. and Mrs. Abbot W. Vose,
Boston, Massachusetts

Abbott Fuller Graves (1859–1936)
Pink and Red Roses
oil on canvas, 38½ × 58
Lamb Collection, Courtesy of
R. H. Love Galleries, Inc., Chicago

Abbott Fuller Graves (1859–1936)
Portsmouth Doorway, ca. 1910
oil on canvas, 24 × 20
Sheila W. and Samuel M. Robbins,
Newton, Massachusetts

Edmund Greacen (1877–1949)
Spring Garden
oil on canvas, 26 × 32
Mr. and Mrs. Haig Tashjian

Eleanor Greatorex (1854–?)
French Flower Market
Watercolor, 10½ × 16½
Katherine B. Page

Philip Leslie Hale (1865–1931)
The Crimson Rambler
oil on canvas, 25 × 30
The Pennsylvania Academy
 of the Fine Arts,
Temple Fund Purchase

Philip Leslie Hale (1865–1931)
Hollyhocks
oil on canvas, 36 × 24
The Butler Institute of American Art,
Youngstown, Ohio

Philip Leslie Hale (1865–1931)
In the Garden
oil on canvas, 30 × 25
Courtesy of Vose Galleries

Jeremiah Hardy (1800–1888)
The Hardy Backyard in Bangor of 1855
oil on canvas, 30 × 20
Mr. Lee B. Anderson

Childe Hassam (1859–1935)
Celia Thaxter in Her Garden, 1892
oil on canvas, 22⅛ × 18⅛
National Museum of American Art,
Smithsonian Institution
Gift of John Gellatly

Childe Hassam (1859–1935)
Flower Girl, ca. 1887–89
oil on canvas, 14¼ × 8⅝
Private Collection

Childe Hassam (1859–1935)
Gathering Flowers in a French Garden,
 1888
oil on canvas, 28 × 21⅝
Worcester Art Museum
Theodore T. and Mary G. Ellis
 Collection

Childe Hassam (1859–1935)
Geraniums, 1888–89
oil on canvas, 18¼ × 13
The Hyde Collection, Glens Falls,
 New York

Childe Hassam (1859–1935)
Home of the Hummingbird, 1893
watercolor on paper, 13¾ × 10⅛
Mr. and Mrs. Arthur G. Altschul

Childe Hassam (1859–1935)
The Isle of Shoals Garden, ca. 1892
watercolor on paper, 19¾ × 13¾
National Museum of American Art,
Smithsonian Institution
Gift of John Gellatly

Childe Hassam (1859–1935)
Laurel in the Ledges, 1906
oil on canvas, 20 × 30
Oliver B. James Collection of American
 Art
Arizona State University Art
 Collections, Tempe

Childe Hassam (1859–1935)
Poppies, Isles of Shoals, 1890
pastel on brown paper, 7¼ × 13¾
Mr. and Mrs. Raymond J. Horowitz

Childe Hassam (1859–1935)
*Celia Thaxter's Garden (Isles of Shoals,
 Maine)*, 1890
oil on canvas, 17½ × 21¼
Private Collection

Childe Hassam (1859–1935)
Reading
oil on panel, 14¼ × 18
The Nelson-Atkins Museum of Art,
 Kansas City, Missouri
Gift from the Howard P. and Tertia
 F.Treadway Collection

Martin Johnson Heade (1819–1904)
Cattleya Orchid with Two Hummingbirds,
 ca. 1880's
oil on canvas, 16¼ × 21¼
The Newark Museum

Albert Herter (1871–1950)
The Herter Family in Paris, ca. 1898
watercolor, 15½ × 11
Mr. and Mrs. George J. Arden

George Hitchcock (1850–1913)
The Flower Seller
oil on canvas, 32 × 26
O'Meara Gallery, Ltd., Sante Fe,
 New Mexico

George Hitchcock (1850–1913)
In Brabant
oil on canvas, 39½ × 24½
Los Angeles County Museum of Art
Gift of Steve Martin

George Hitchcock (1850–1913)
Lady in a Field of Hyacinths
oil on canvas, 22¼ × 17¼
Paul H. Buchanan, Jr.

George Hitchcock (1850–1913)
The Poppy Field
oil on canvas, 51¼ × 65
Ira Spanierman, Inc., New York

George Hitchcock (1850–1913)
Spring Near Egmond
oil on canvas, 16½ × 21½
Donald R. and Kathryn O'C. Counts

Winslow Homer (1836–1910)
Flower Garden and Bungalow, Bermuda
watercolor on paper, 14 × 21
The Metropolitan Museum of Art
Amelia B. Lazarus Fund, 1910

Winslow Homer (1836–1910)
Girl in a Garden, 1878
watercolor on paper, 6½ × 8½
Scripps College, Claremont, California
Gift of General and Mrs. Edward
 Clinton Young, 1946

Thomas Hovenden (1840–1895)
Springtime, ca. 1892
oil on canvas, 18 × 22
Nancy Corson

Eastman Johnson (1824–1906)
Catching the Bee, 1872
oil on canvas, 22 × 13¾
The Newark Museum

Francis Coates Jones (1857–1932)
Flower Garden, 1922
oil on panel, 20⅝ × 24¾
Private Collection

Daniel Ridgway Knight (1839–1924)
Normandy Girl Sitting in Garden
oil on canvas, 32 × 25⅞
Mr. Frank Dickstein

John La Farge (1835–1910)
Water Lily
oil on canvas, 12½ × 10½
Mead Art Museum, Amherst College

George Lambdin (1830–1896)
Roses in a Wheelbarrow
oil on canvas, 22¼ × 30
Lamb Collection, Courtesy of
R. H. Love Galleries, Inc. Chicago

George Lambdin (1830–1896)
Roses on the Wall, 1874
oil on canvas, 19¾ × 15¾
Mr. and Mrs. William C. Burt

George Lambdin (1830–1896)
Rosy Reverie, 1865
oil on canvas, 24 × 20
Board of Governors of the Federal
 Reserve System, Washington, D.C.

George Lambdin (1830–1896)
Wisteria on a Wall, 1871
oil on board, 22 × 16
Mr. and Mrs. Charles C. Shoemaker

Ernest Lawson (1873–1939)
The Garden, 1914
oil on canvas, 20 × 24
Memorial Art Gallery of the University
 of Rochester
Rochester, New York
Gift of the Estate of Emily and James
 Sibley Watson, 1951

Ernest Lawson (1873–1939)
Garden Landscape
oil on canvas, 20 × 24
The Brooklyn Museum
Bequest of Laura L. Barnes

Jean Mannheim (1863–1945)
Our Wisteria, ca. 1912
oil on canvas, 24 × 20
Mr. and Mrs. Frank Duncan

Gari Melchers (1860–1932)
Lily Pond, ca. 1925
oil on canvas, 22 × 31
Mr. and Mrs. Leslie Cheek, Jr.

Willard Metcalf (1858–1925)
The Poppy Garden, 1905
oil on canvas, 24 × 24
Private Collection

Willard Metcalf (1858–1925)
Purple, White and Gold, 1903
oil on canvas, 26 × 18
Private Collection, Courtesy of Ameri-
 can Tradition Gallery, Greenwich,
 Connecticut

Francis David Millet (1846–1912)
The Poppy Field, 1884
oil on wood panel, 16¼ × 9¼
Jo Ann and Julian Ganz, Jr.

Claude Monet (1840–1926)
Poppy Field Near Giverny, 1885
oil on canvas, 25⅝ × 32
Juliana Cheney Edwards Collection
Bequest of Robert J. Edwards in
 memory of his mother
Museum of Fine Arts, Boston

F. Luis Mora (1874–1940)
Peonies, 1916
oil on board, 11½ × 16
Arthur J. Phelan, Jr.

Henry Siddons Mowbray (1858–1928)
Roses, ca. 1900
oil on canvas, 12 × 16¼
National Academy of Design, New
 York City

Henry Roderick Newman (1833–1918)
Anemones, 1876
watercolor on paper, 18 × 11¾
Private Collection courtesy of
Jeffrey R. Brown Fine Arts, Inc.

Julian Onderdonk (1882–1922)
Bluebonnet Field, 1912
oil on canvas, 20 × 30
San Antonio Museum Association
Gift of Grace Irving Gosling

Julian Onderdonk (1882–1922)
Cactus Flower
oil on canvas, 16 × 20
San Antonio Museum Association
Gift of Mrs. Ernest L. Brown, Sr. and
 Mr. Ernest L. Brown, Jr. in memory
 of Ernest L. Brown Sr. and Mrs.'
 Ernest L. Brown, Jr.

Lawton S. Parker, (1868–1954)
Woman in a Garden
oil on canvas, 24 × 24
Furman Collection, Courtesy of
R. H. Love Galleries, Inc., Chicago

Maurice Prendergast (1859–1924)
Italian Flower Market, 1898
pencil and watercolor, 14½ × 10
Dr. and Mrs. Irving Levitt

Maurice Prendergast (1859–1924)
Rhododendrons, Boston Public Gardens,
 1899

watercolor and pencil on paper,
14 × 20½
The Joan Whitney Payson Gallery of
 Art, Westbrook College,
 Portland, Maine
The Joan Whitney Payson Collection

Joseph Raphael (1872–1950)
Tulip Field, Holland, 1913
oil on canvas, 29 × 29
Stanford University Museum of Art
Gift of Morgan Gunst

Joseph Raphael (1872–1950)
The Garden, 1915
oil on canvas, 28¼ × 30¼
John H. Garzoli Fine Art

Granville Redmond (1871–1935)
California Poppy Field
oil on canvas, 40 × 60¼
Los Angeles County Museum of Art
Gift of Raymond Griffith

Robert Reid (1862–1929)
The White Parasol
oil on canvas, 36 × 30
National Museum of American Art,
 Smithsonian Institution
Gift of William T. Evans

William Trost Richards (1833–1905)
*A Summer Afternoon in a Garden in
 Philadelphia*, 1859
oil on canvas, 11½ × 14¾
Private Collection

Ellen Robbins (1828–1905)
On the Forest Edge, 1896
watercolor on paper, 13 × 18
Sheila W. and Samuel M. Robbins,
 Newton, Massachusetts

Edward F. Rook (1870–1960)
Laurel, ca. 1905–1910
oil on canvas, 40½ × 50¼
Mrs. Helen K. Fusscas

John Singer Sargent (1856–1925)
F. D. Millet House and Garden, 1886
oil on canvas, 27 × 35
Mrs. John W. Griffith, Dallas, Texas

John Singer Sargent (1856–1925)
Roses, 1901
watercolor, 13¾ × 10
The Ormond Family

John Singer Sargent (1856–1925)
Roses in Oxfordshire, 1885
oil on canvas, 27 × 17
Mr. and Mrs. J. Douglas Pardee,
A Private Collection

Walter Shirlaw (1838–1909)
Poppies
oil on academy board, 18 × 14
Hirschl & Adler Galleries, Inc.,
 New York

John Sloan (1871–1951)
Easter Eve, 1907
oil on canvas, 32 × 26½
Private Collection

Louis Comfort Tiffany (1848–1933)
At Irvington on Hudson
oil on canvasboard, 24½ × 18½
Nebraska Art Association, Courtesy of
 Sheldon Memorial Art Gallery,
University of Nebraska-Lincoln

Helen M. Turner (1858–1958)
Morning, 1919
oil on canvas, 34½ × 44½
Zigler Museum, Jennings, Louisiana

Ross Turner, (1847–1915)
A Garden is a Sea of Flowers, 1912
watercolor on paper, 20½ × 30½
Museum of Fine Arts, Boston
Gift of the Estate of Nellie P. Carter,
 1935

John Twachtman (1853–1902)
Azaleas, ca. 1898
oil on canvas, 30 × 24
Maier Museum of Art
Randolph-Macon Woman's College
Lynchburg, Virginia

John Twachtman (1853–1902)
In the Greenhouse
oil on canvas, 25 × 16
North Carolina Museum of Art,
 Raleigh

John Twachtman (1853–1902)
Meadow Flowers, ca. 1890–1900
oil on canvas, 33¹⁄₁₆ × 22¹⁄₁₆
The Brooklyn Museum
Caroline H. Polhemus Fund

John Twachtman (1853–1902)
Tiger Lillies
oil on canvas, 30 × 22
Mr. and Mrs. Meyer P. Potamkin

Luther Emerson van Gorder
 (1861–1931)
Japanese Lanterns, 1895
oil on canvas, 28¼ × 22½
Tweed Museum of Art
George P. Tweed Memorial Art
 Collection

Luther Emerson van Gorder
 (1861–1931)
Quai aux Fleurs, Paris
oil on canvas, 36 × 48
The Toledo Museum of Art
Gift of the Tile Club, Toledo

Robert Vonnoh (1858–1933)
Flanders Field, ca. 1892
oil on canvas, 58 × 104
The Butler Institute of American Art
Youngstown, Ohio

Clark G. Voorhees (1871–1933)
My Garden, ca. 1914
oil on linen, 28¾ × 36
Michael Wren Voorhees

Theodore Wores (1859–1939)
Chrysanthemum Show, Yokohama
oil on panel, 16 × 20
Drs. Ben and A. Jess Shenson

Theodore Wores (1859–1939)
My Studio Garden, 1926
oil on canvas, 16¾ × 19¾
Triton Museum of Art

Index

Page numbers in italics indicate illustrations.